Adult Coloring Book Collection

Stress Relief Coloring Book

Animals, Mandalas, Flowers, Butterflies and Patterns Designs

By

Engy Khalil

Copyrighted Material

All Rights Reserved. No part of publication may be reproduced in any form or any means, including photocopying, scanning or another way without prior written permission of the copyright material holder.

Copyrighted © 2017 Engy Khalil

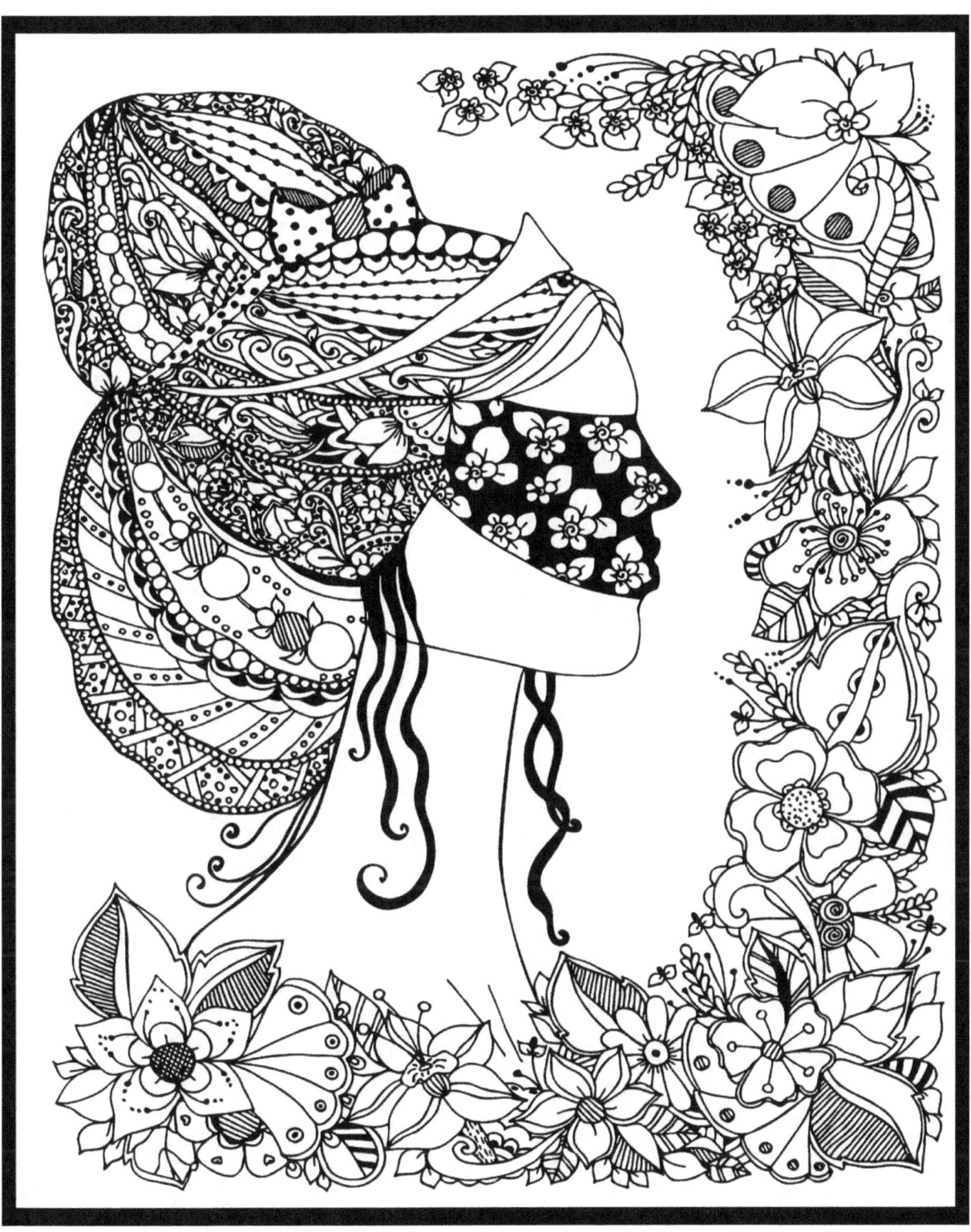

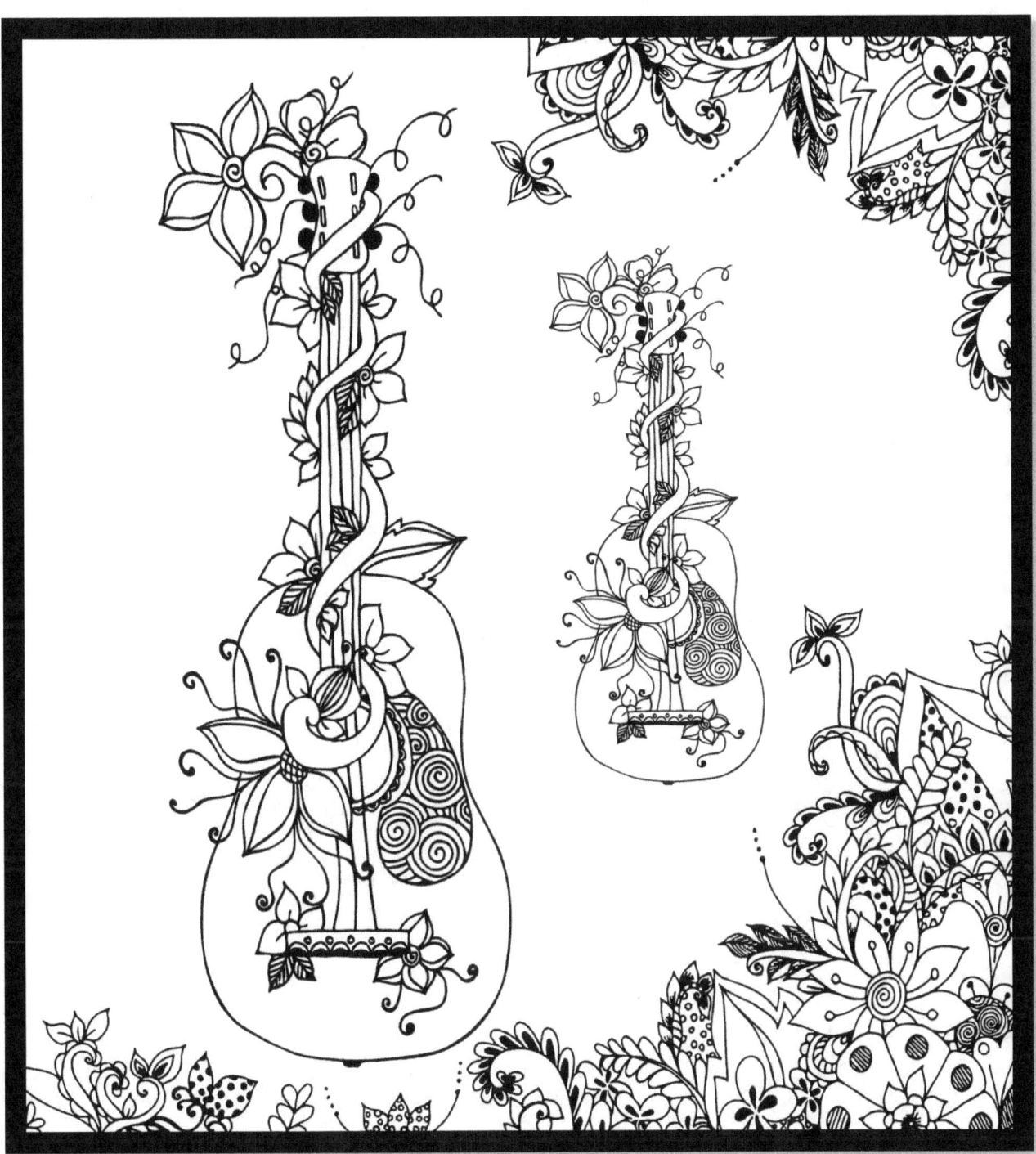

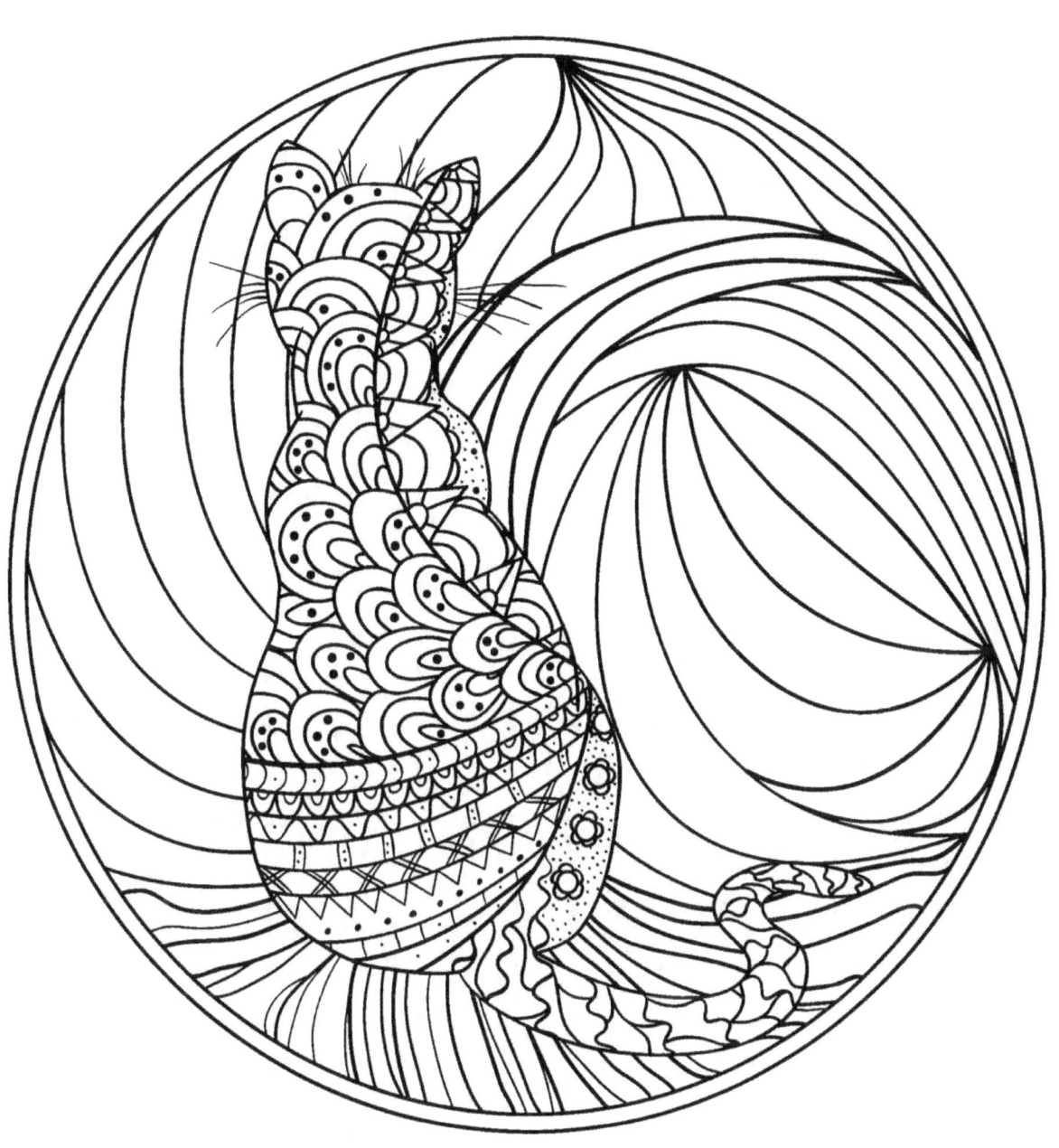

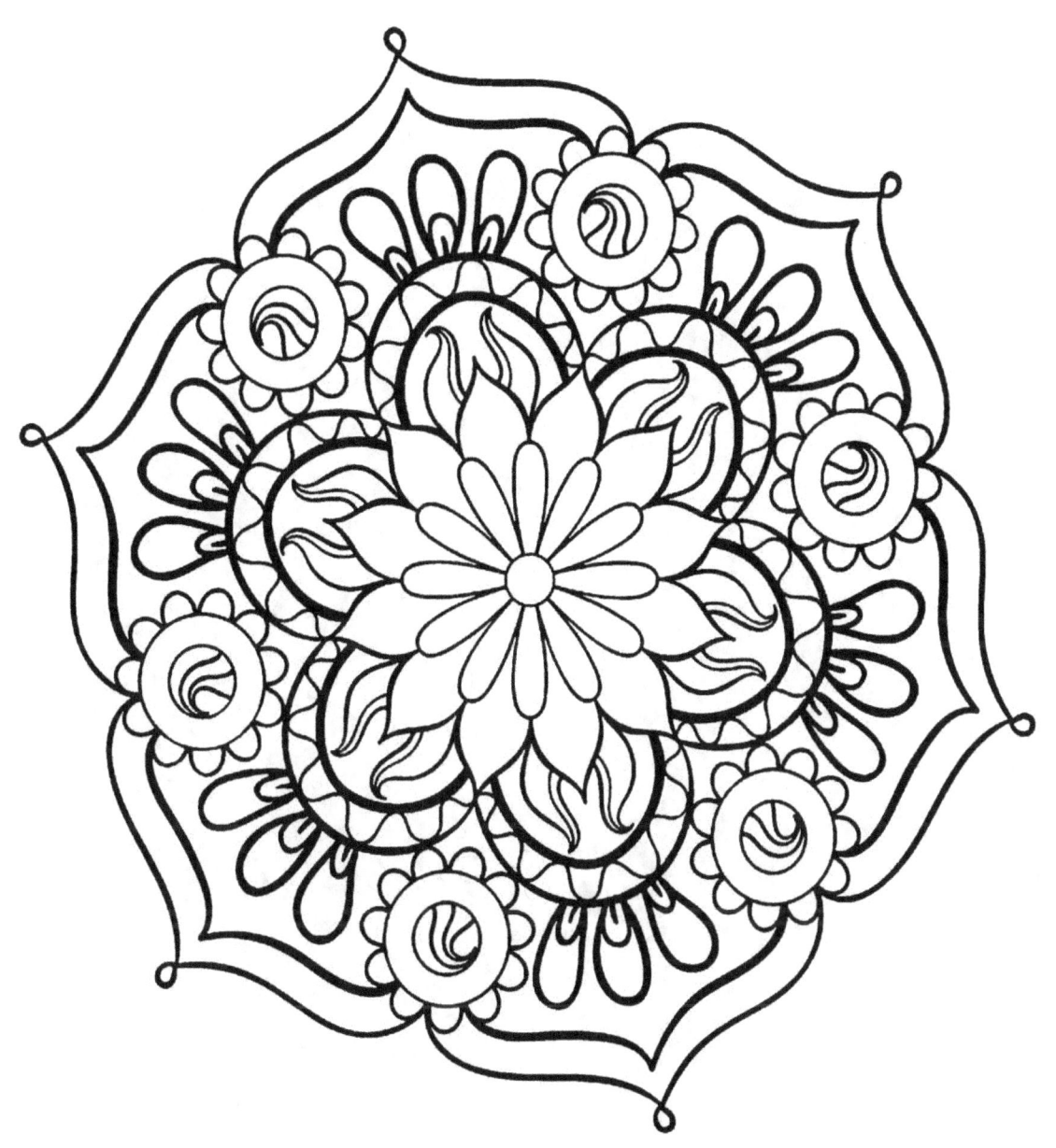

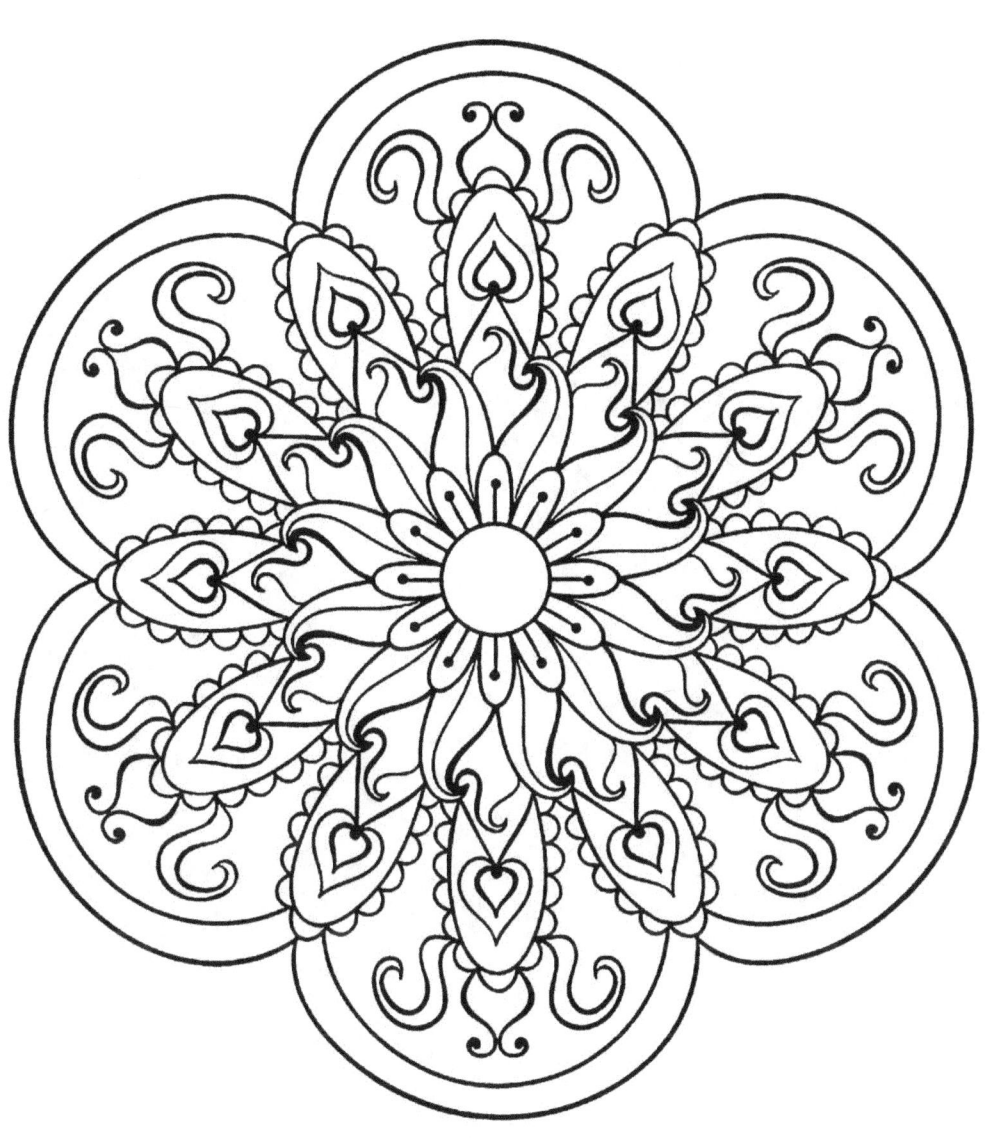

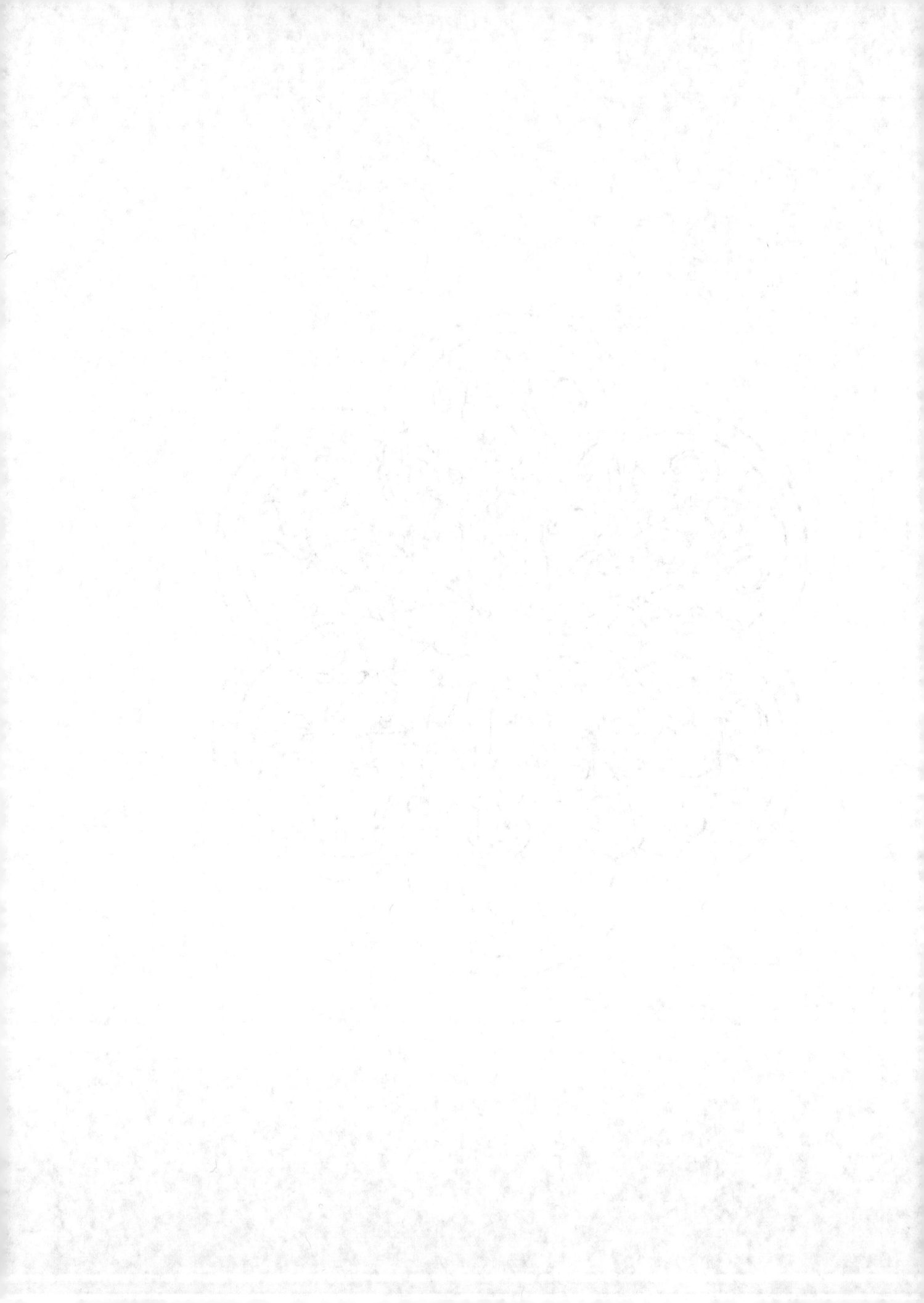

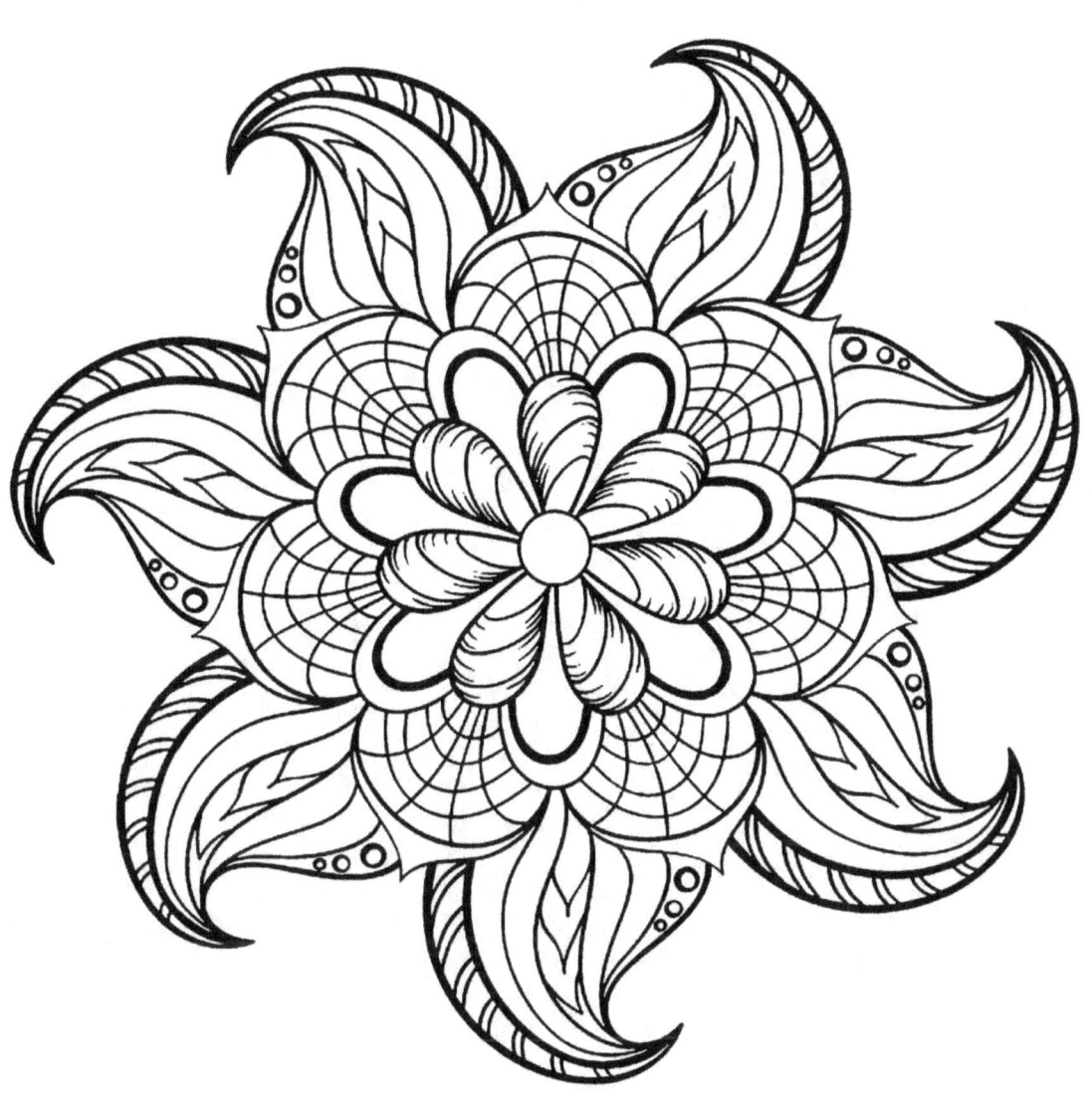

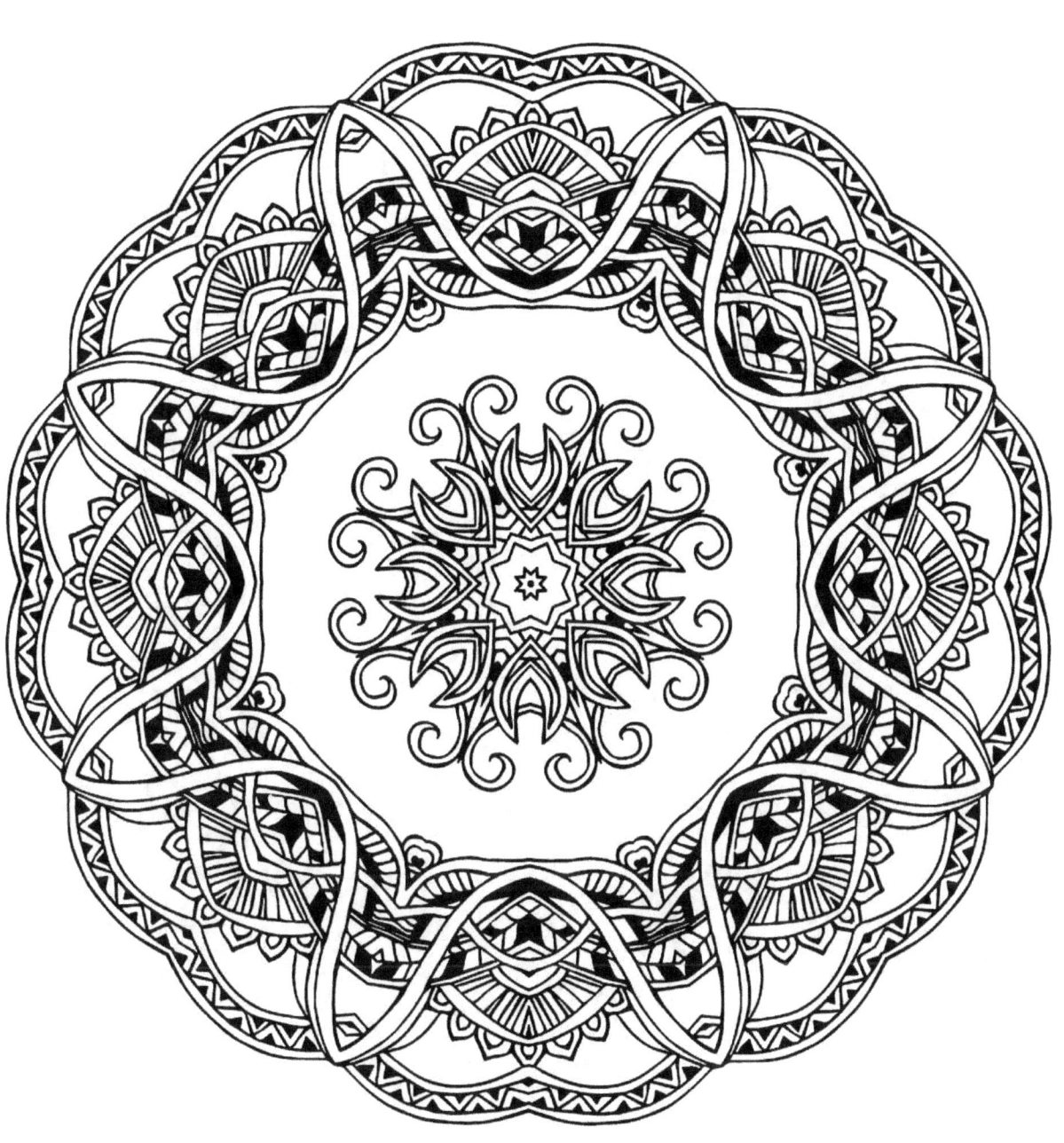

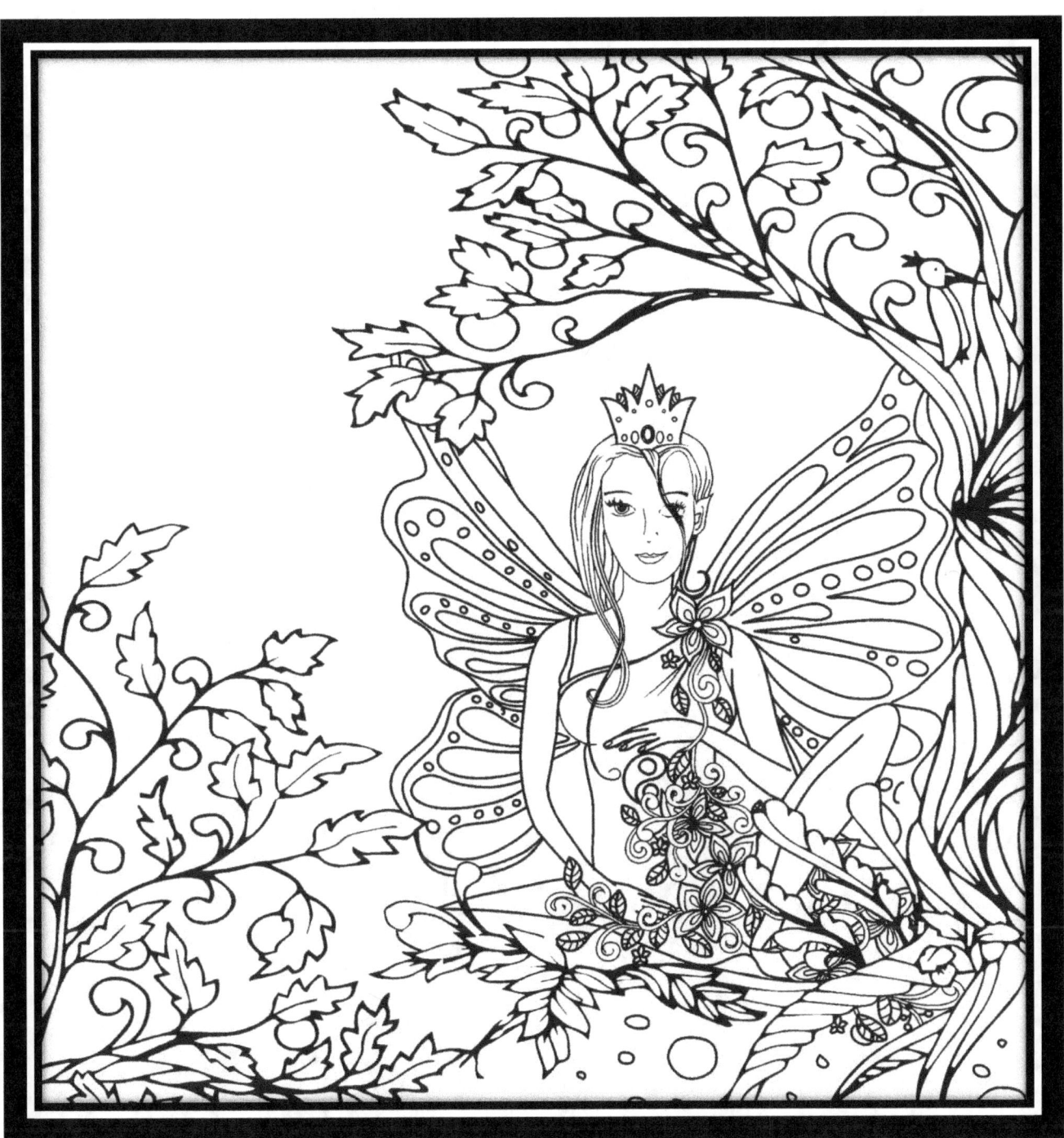

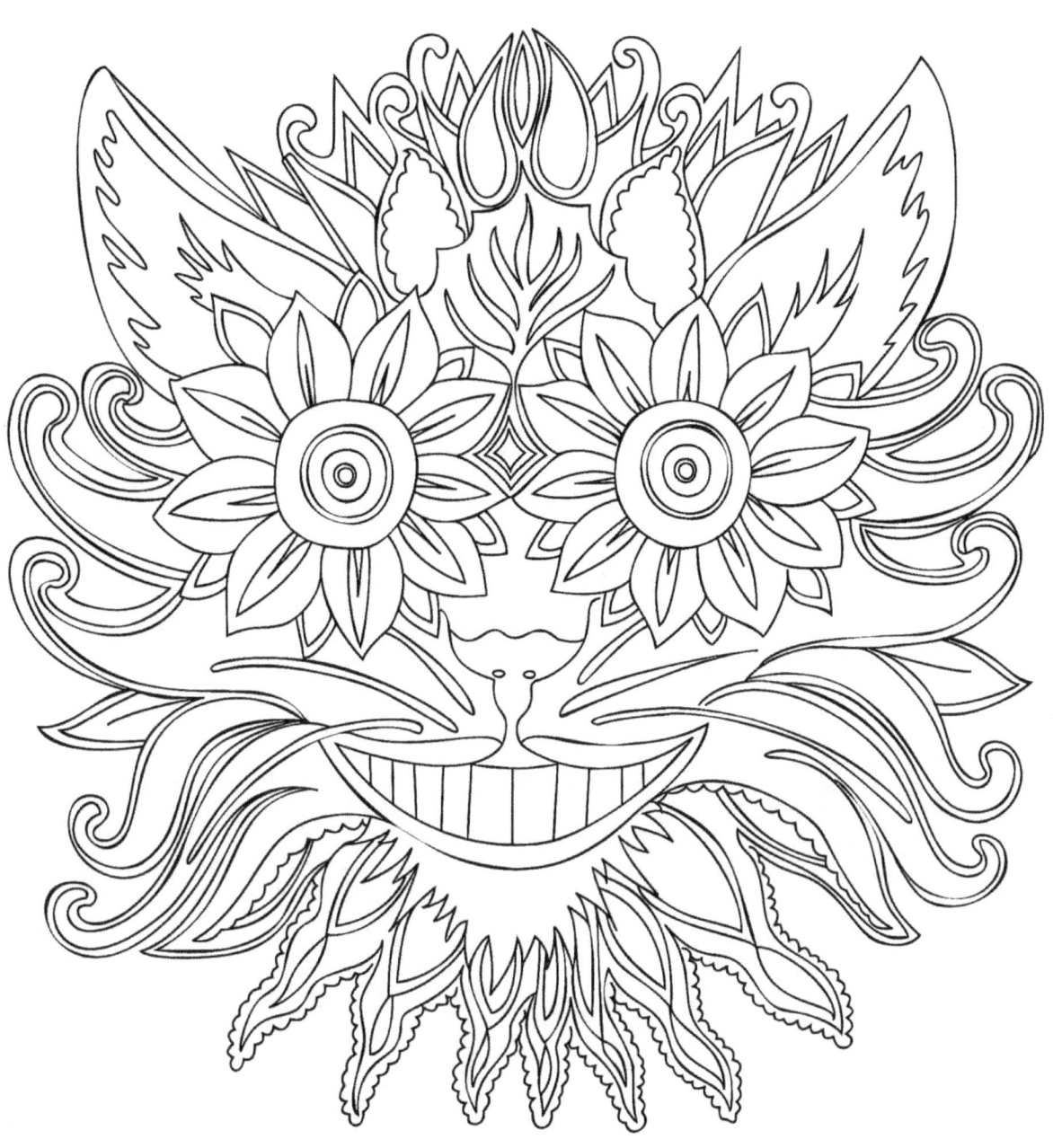

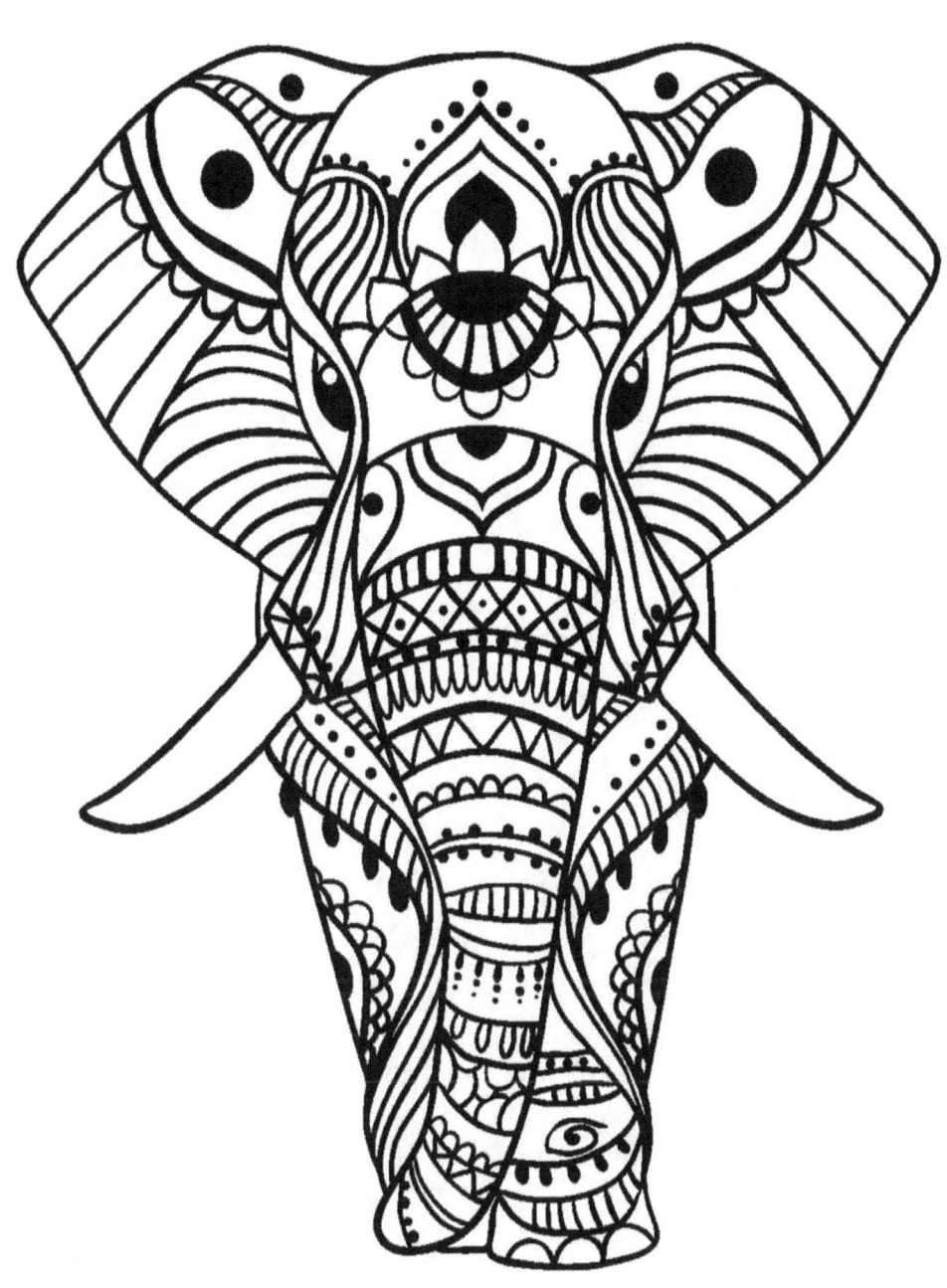

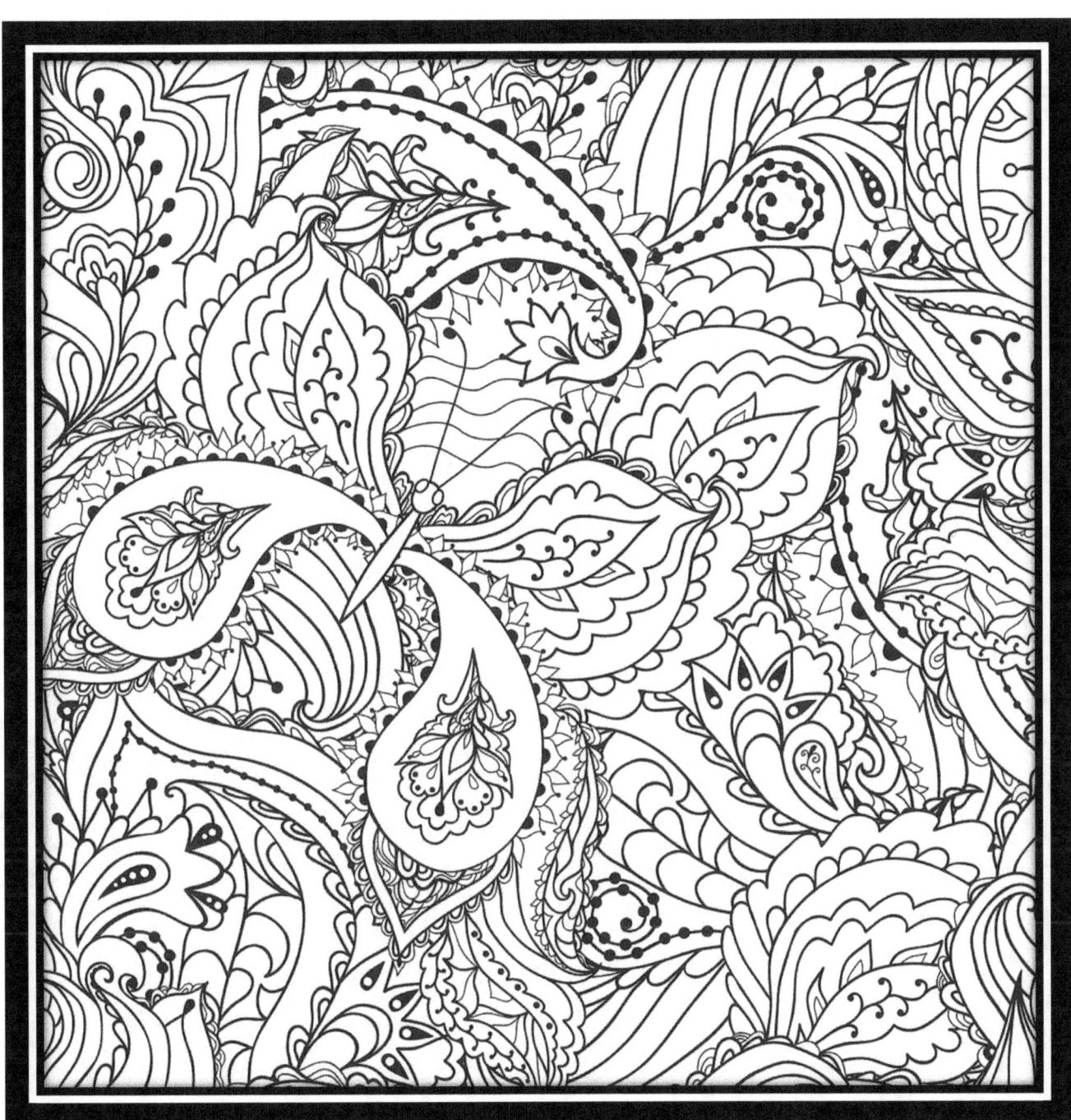

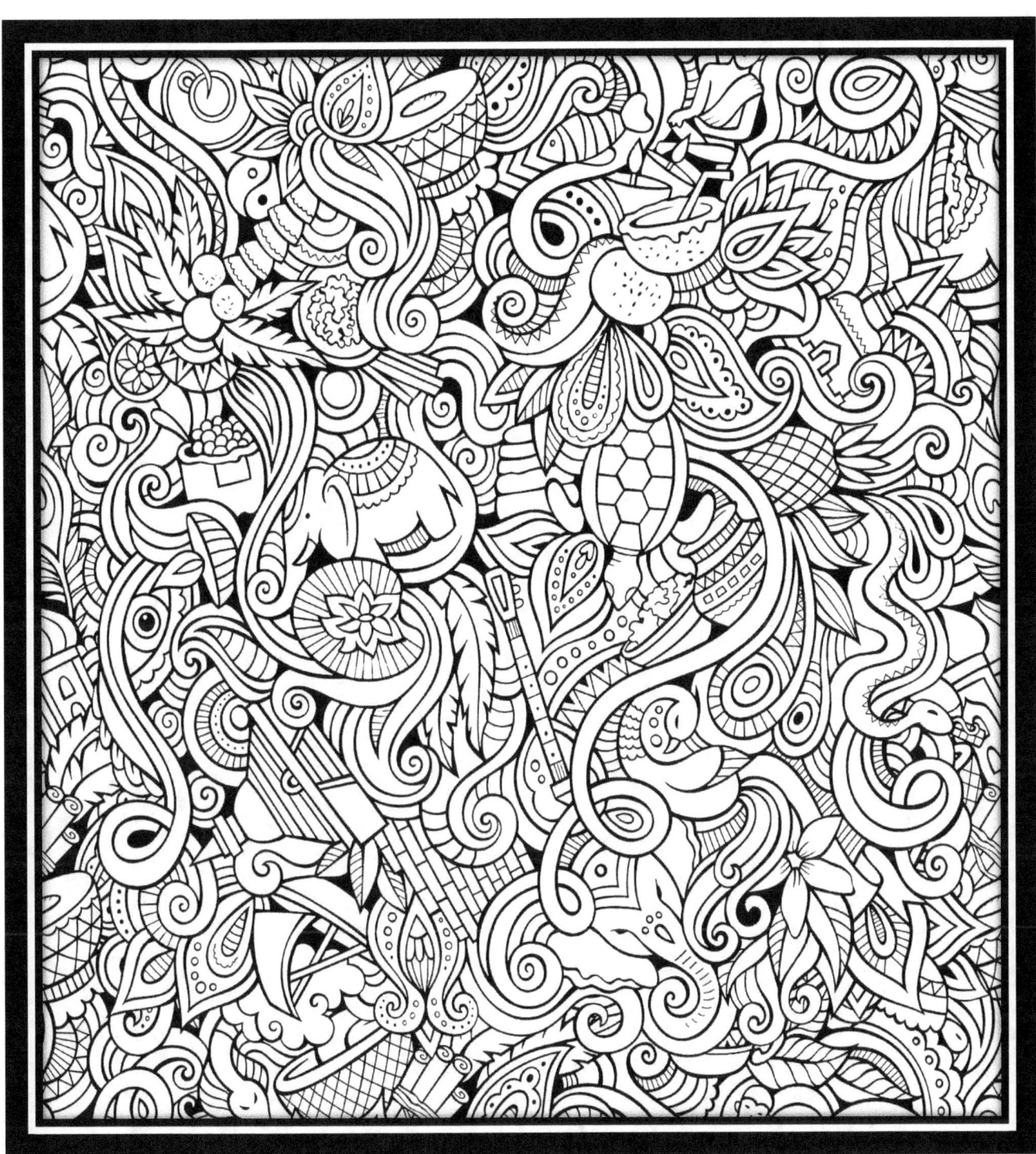

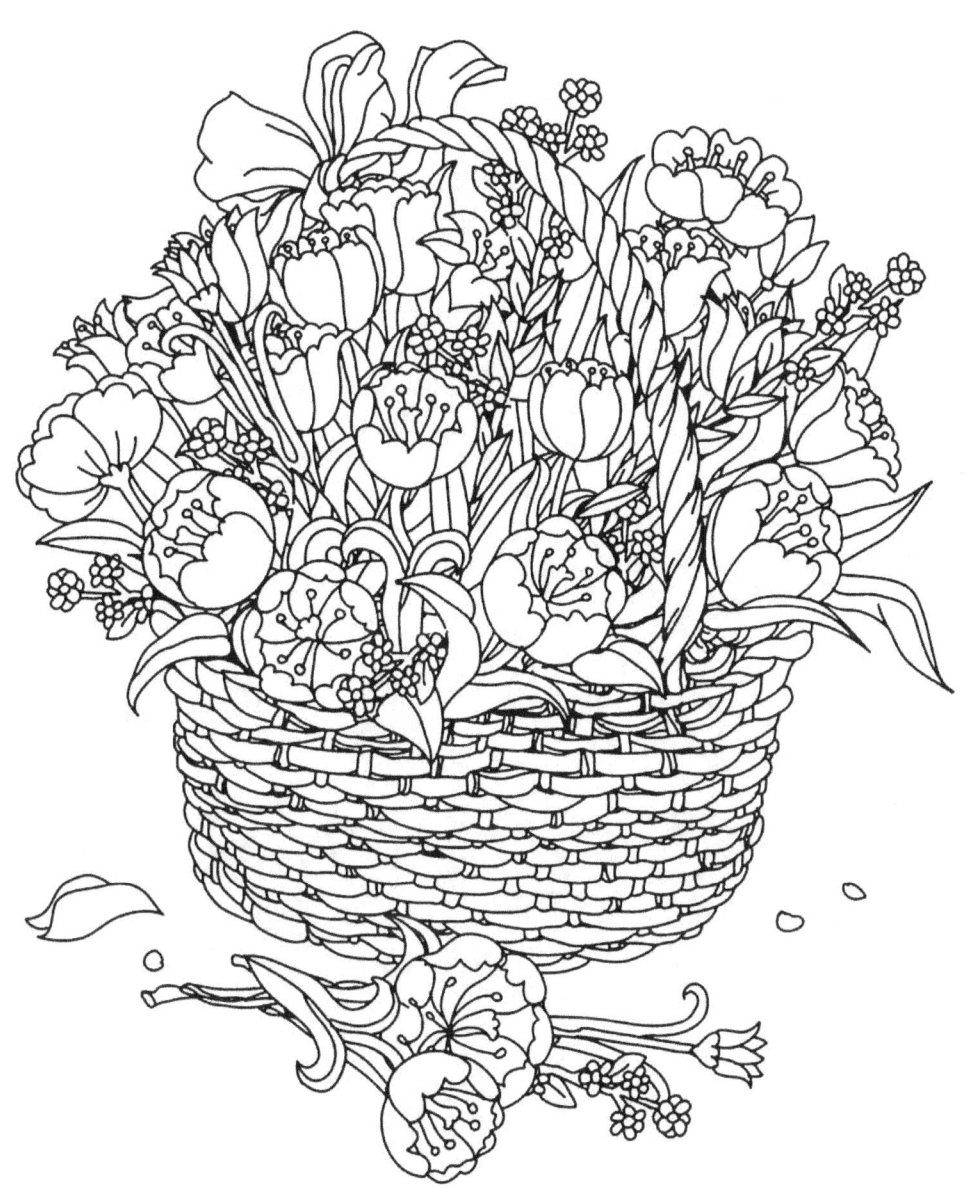

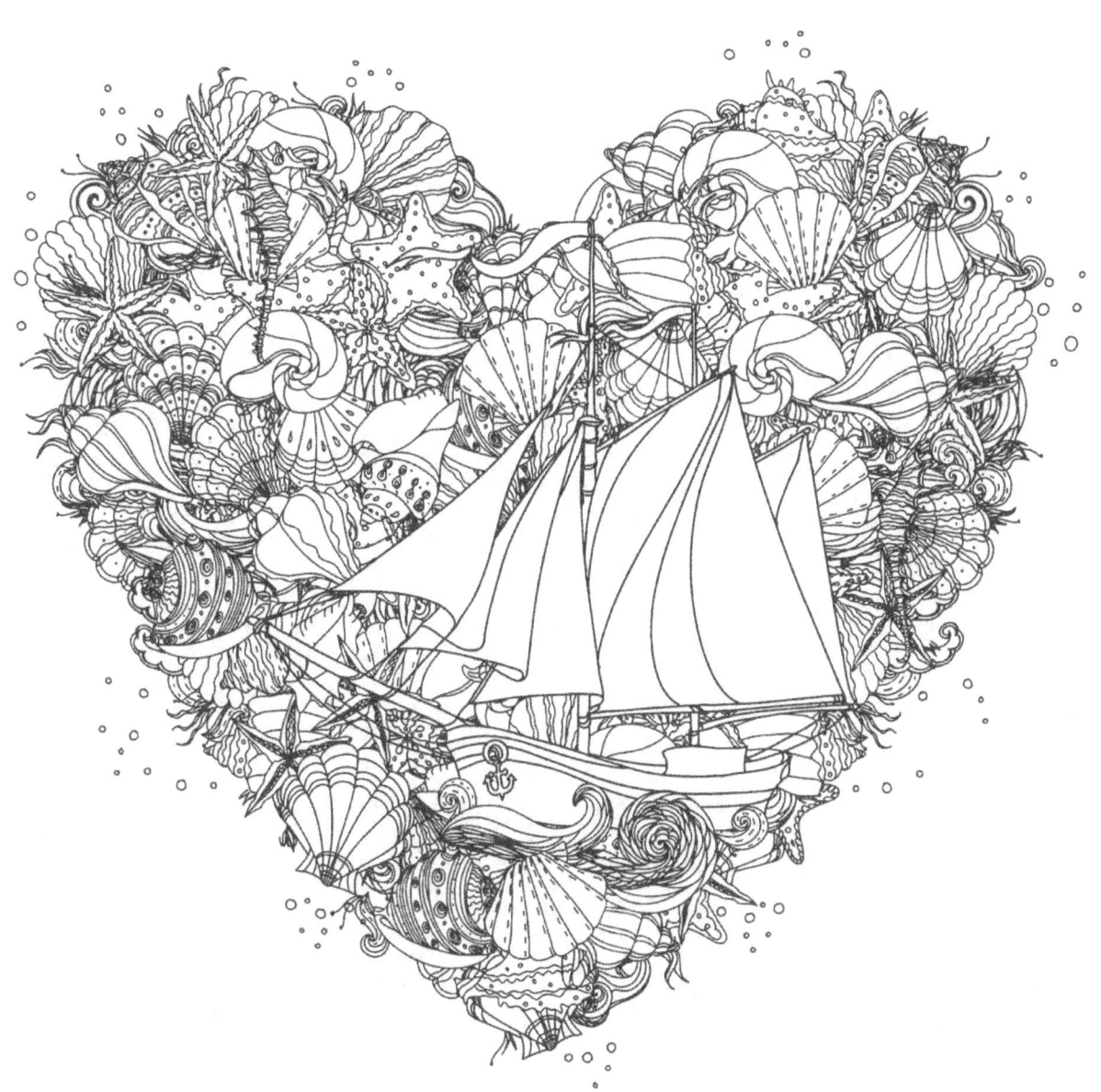

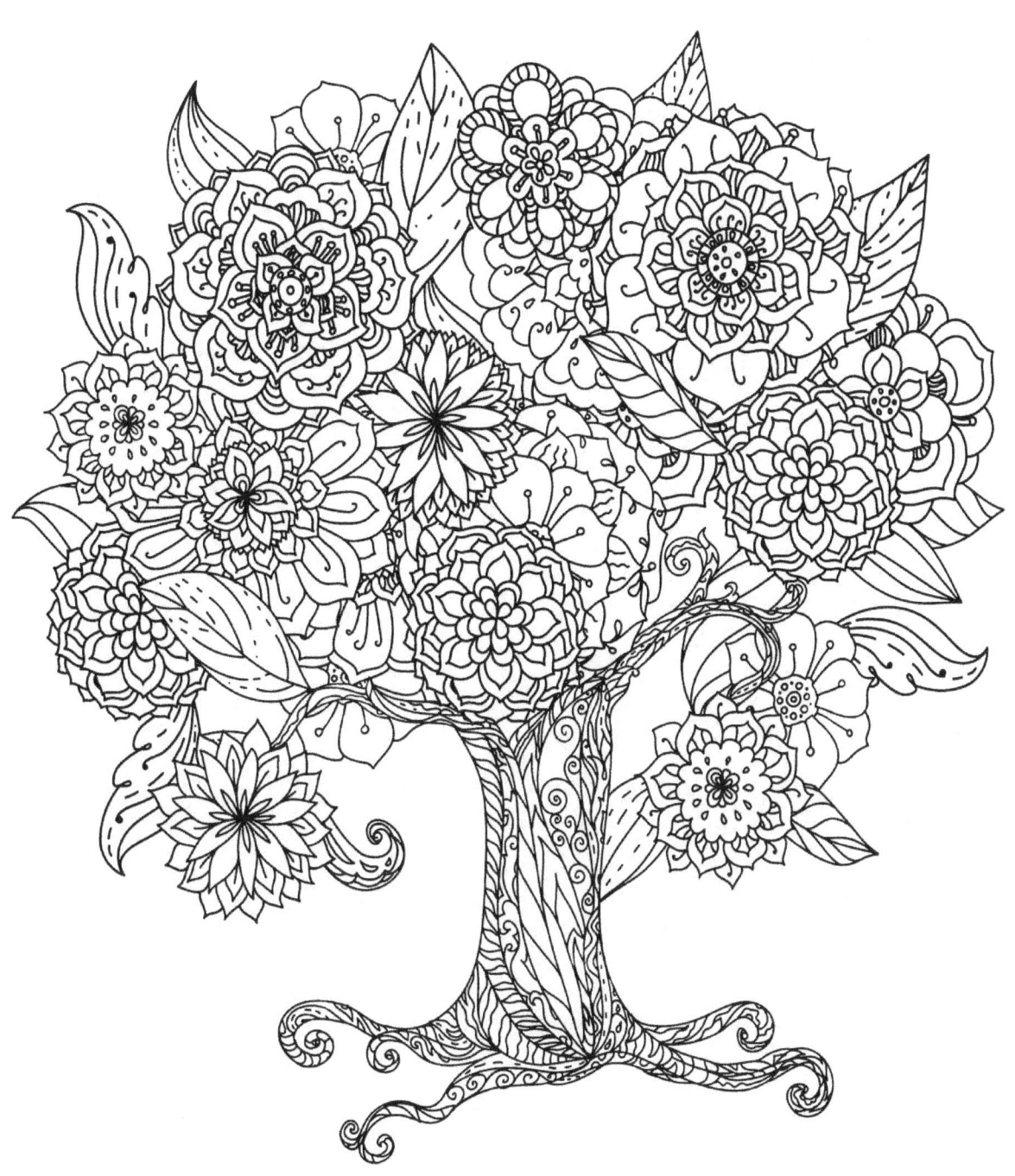

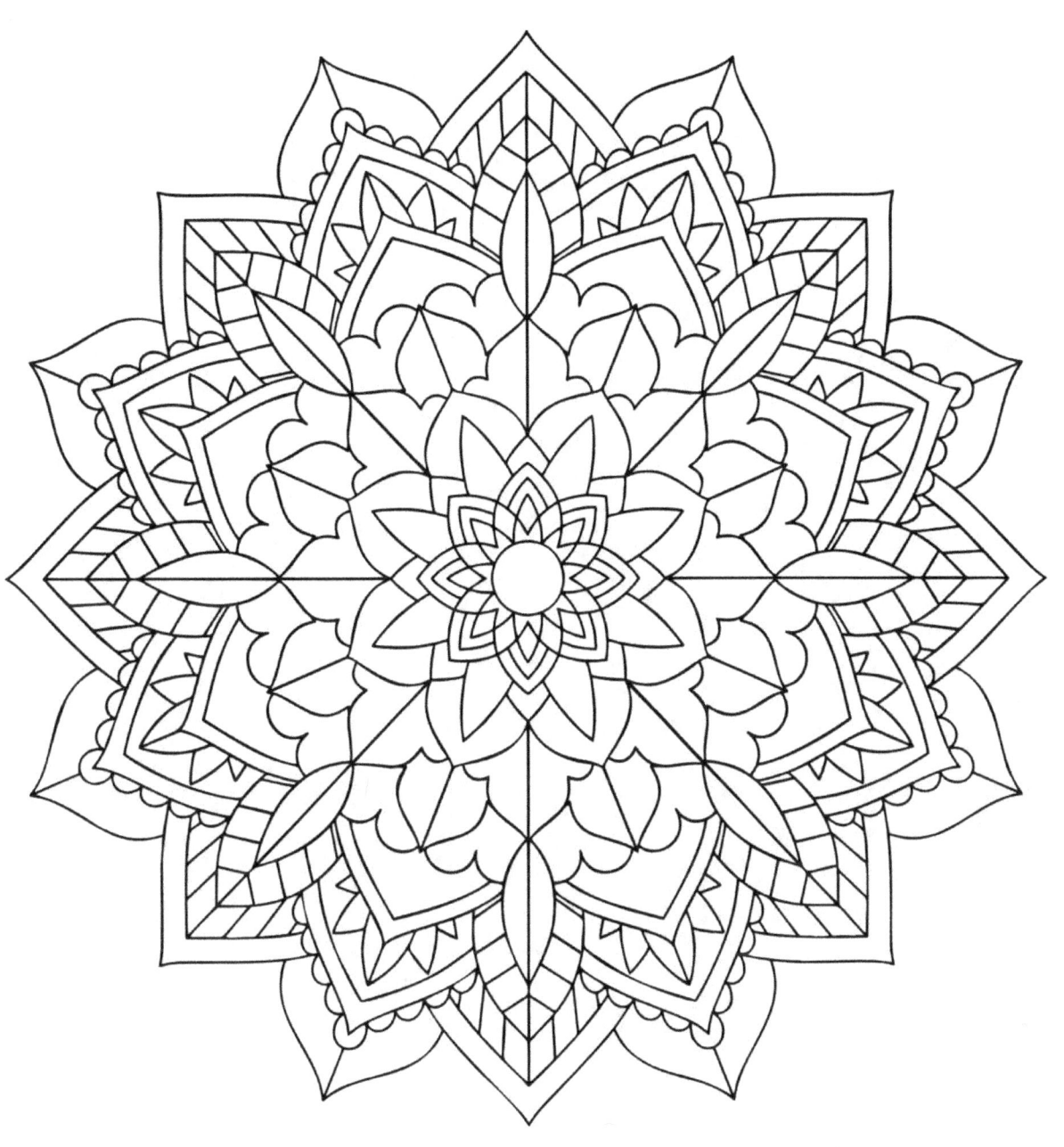

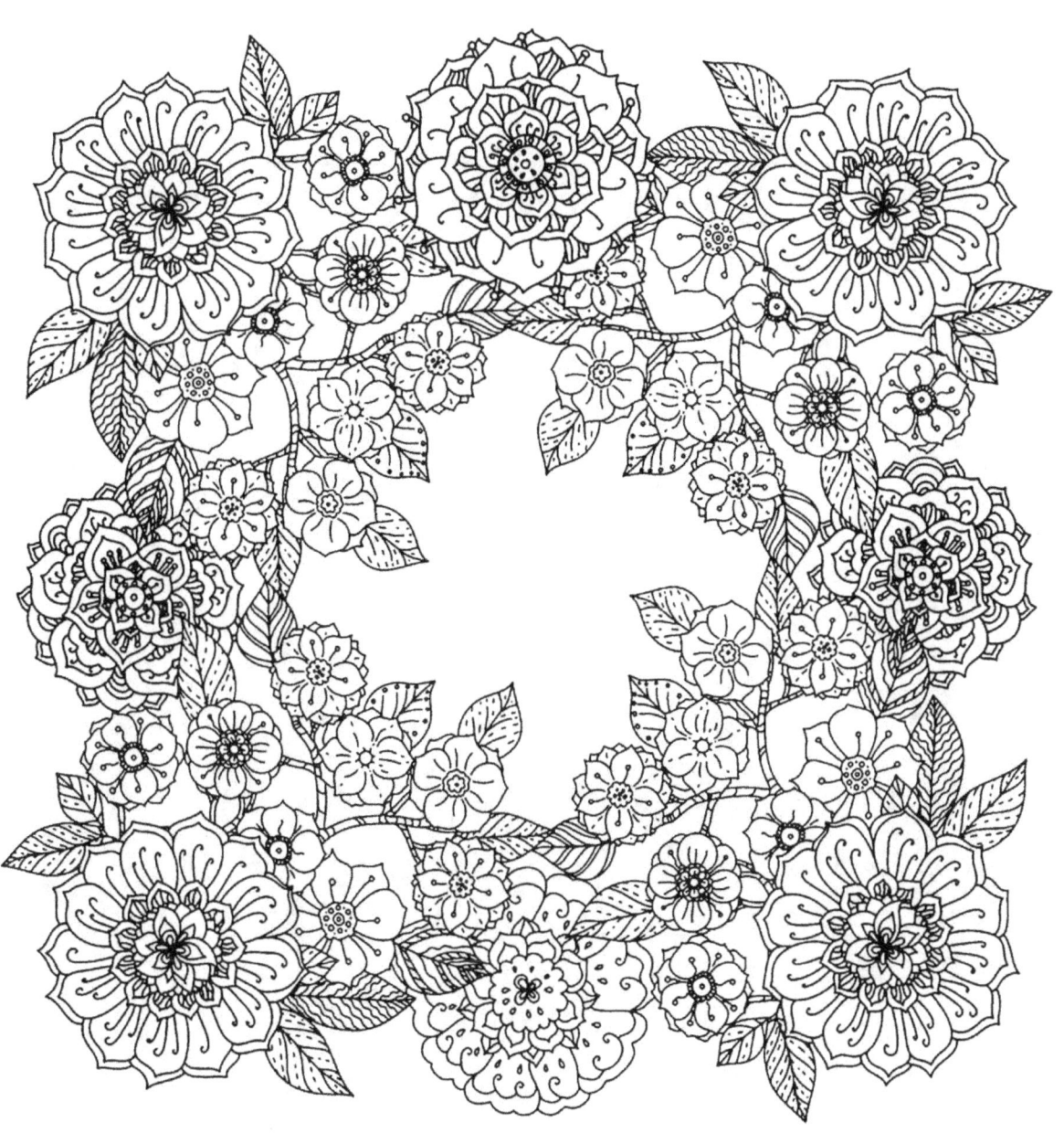

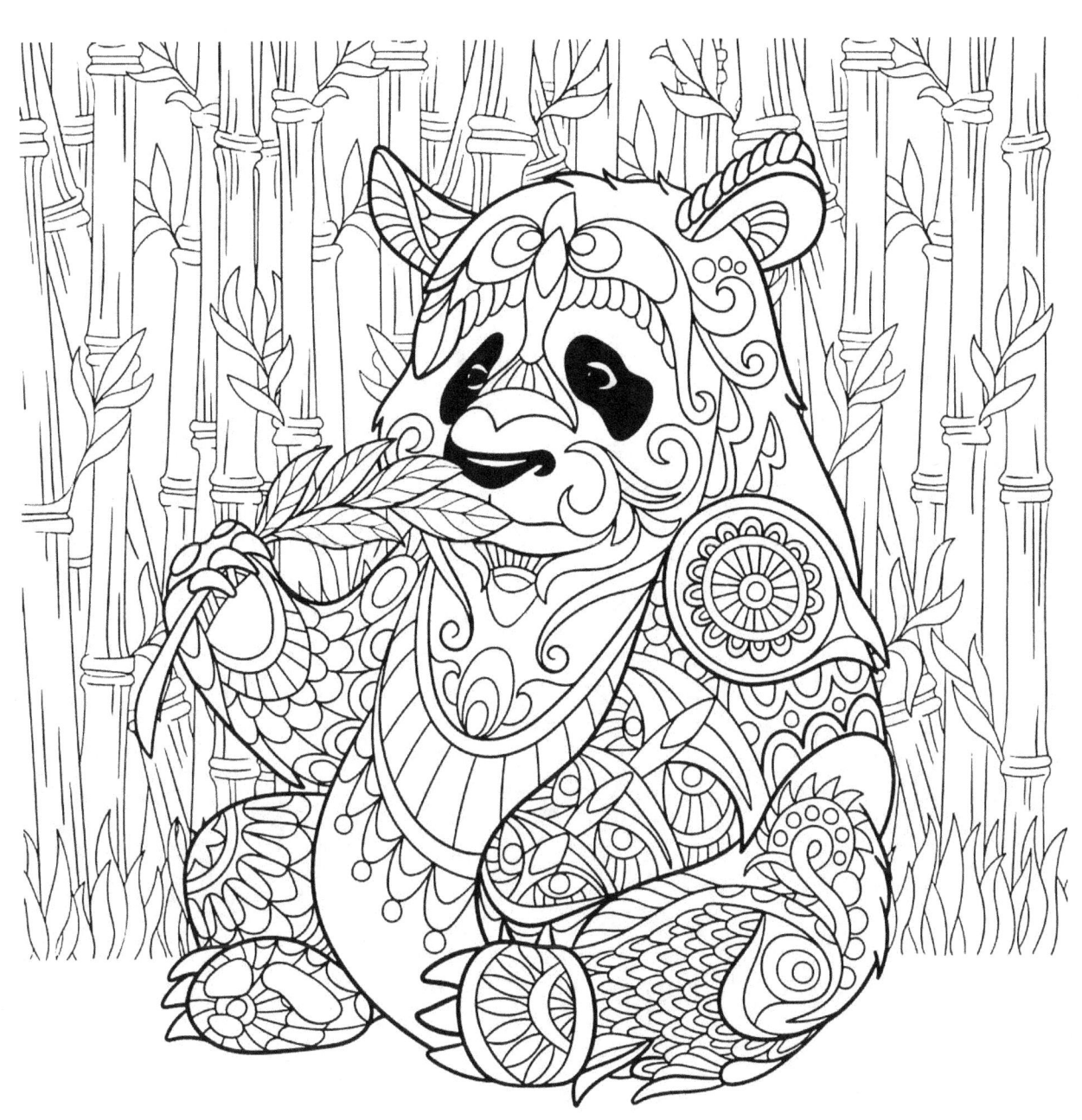

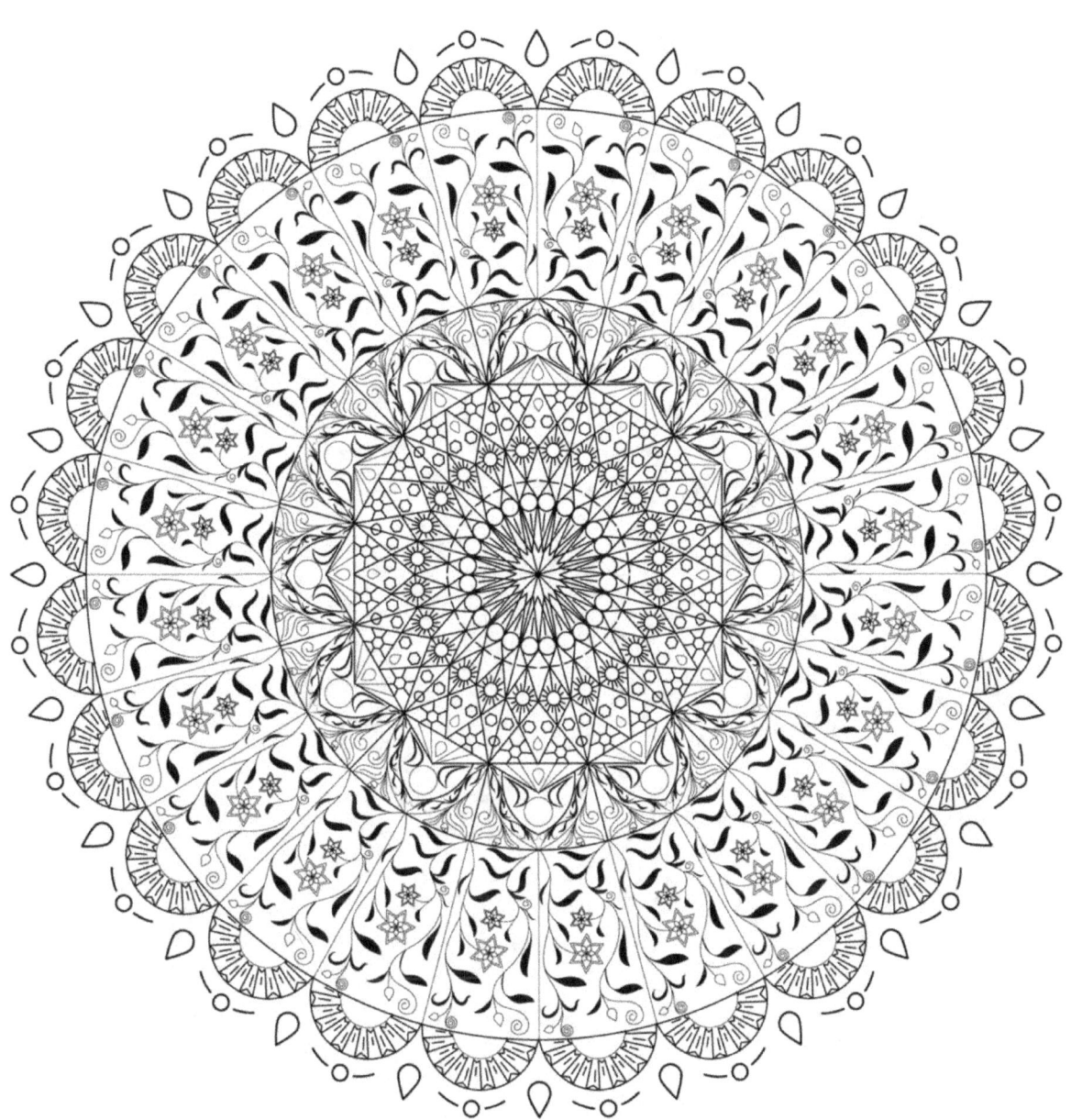

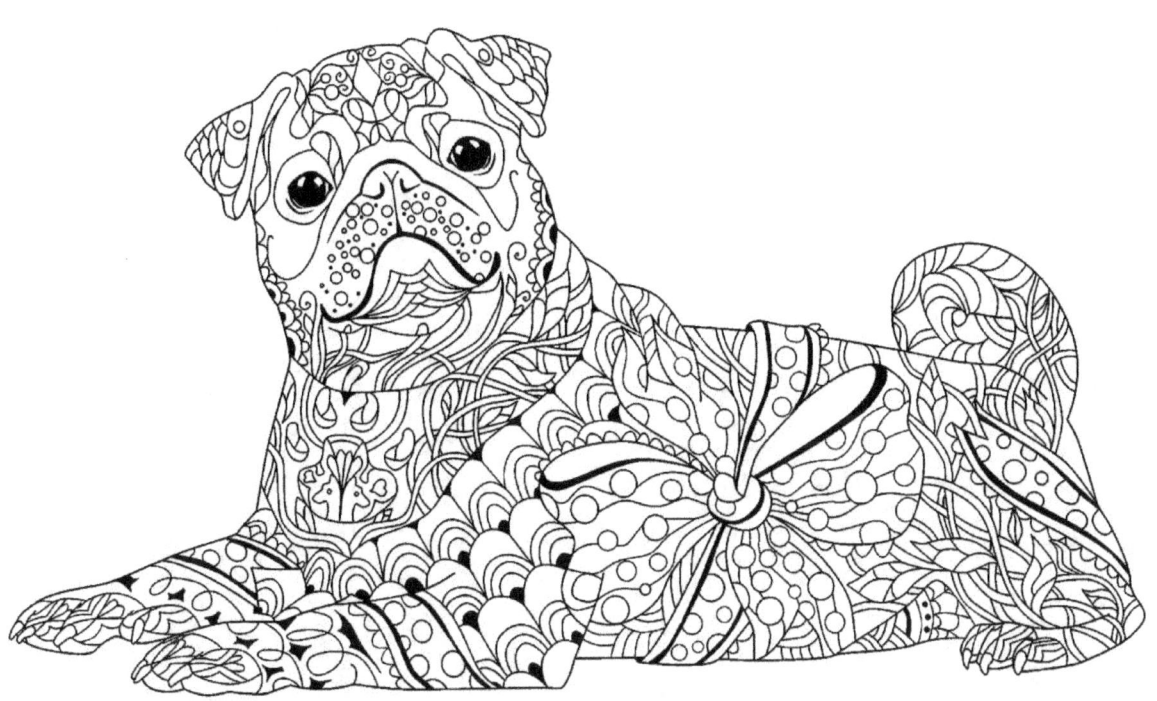

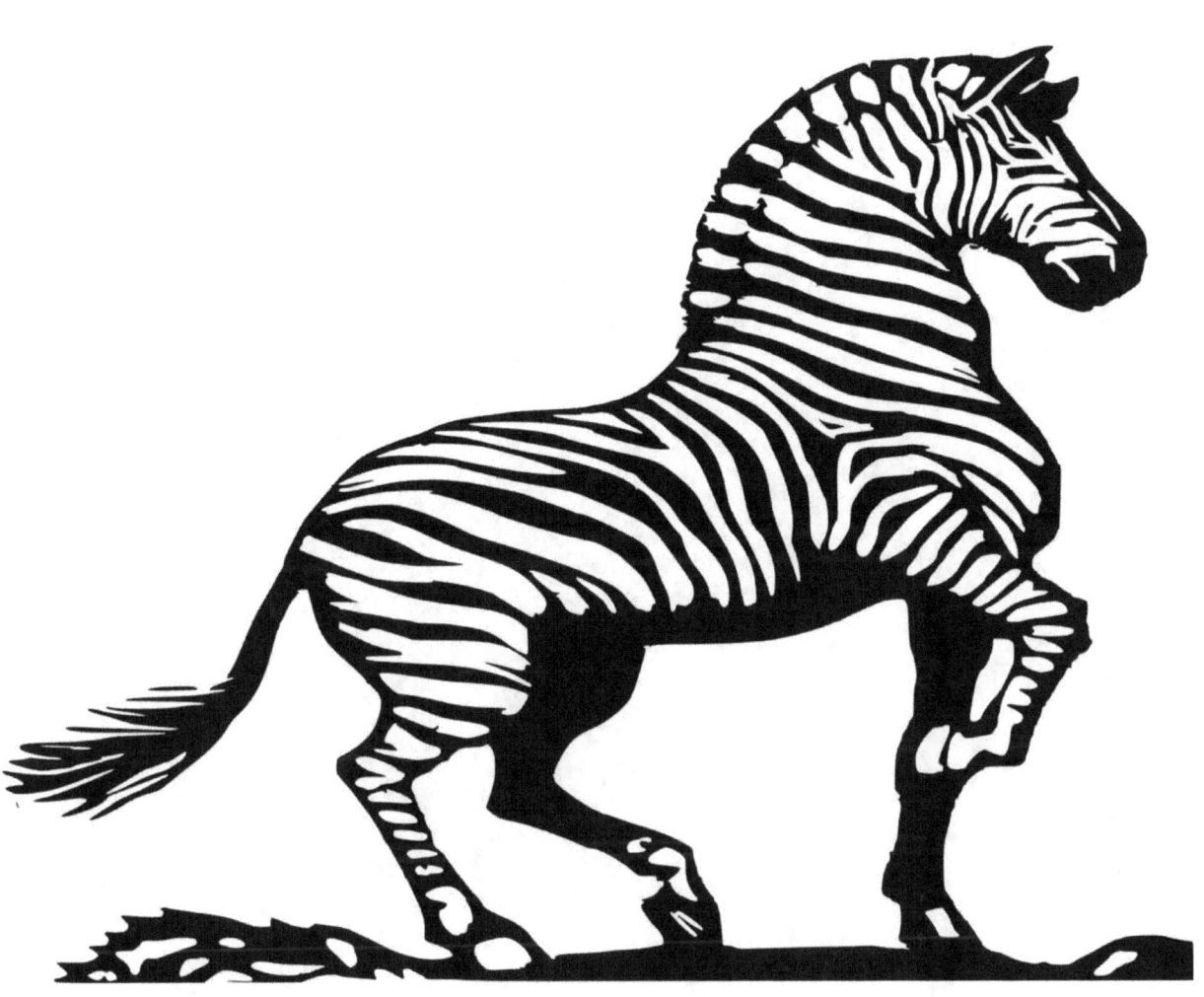

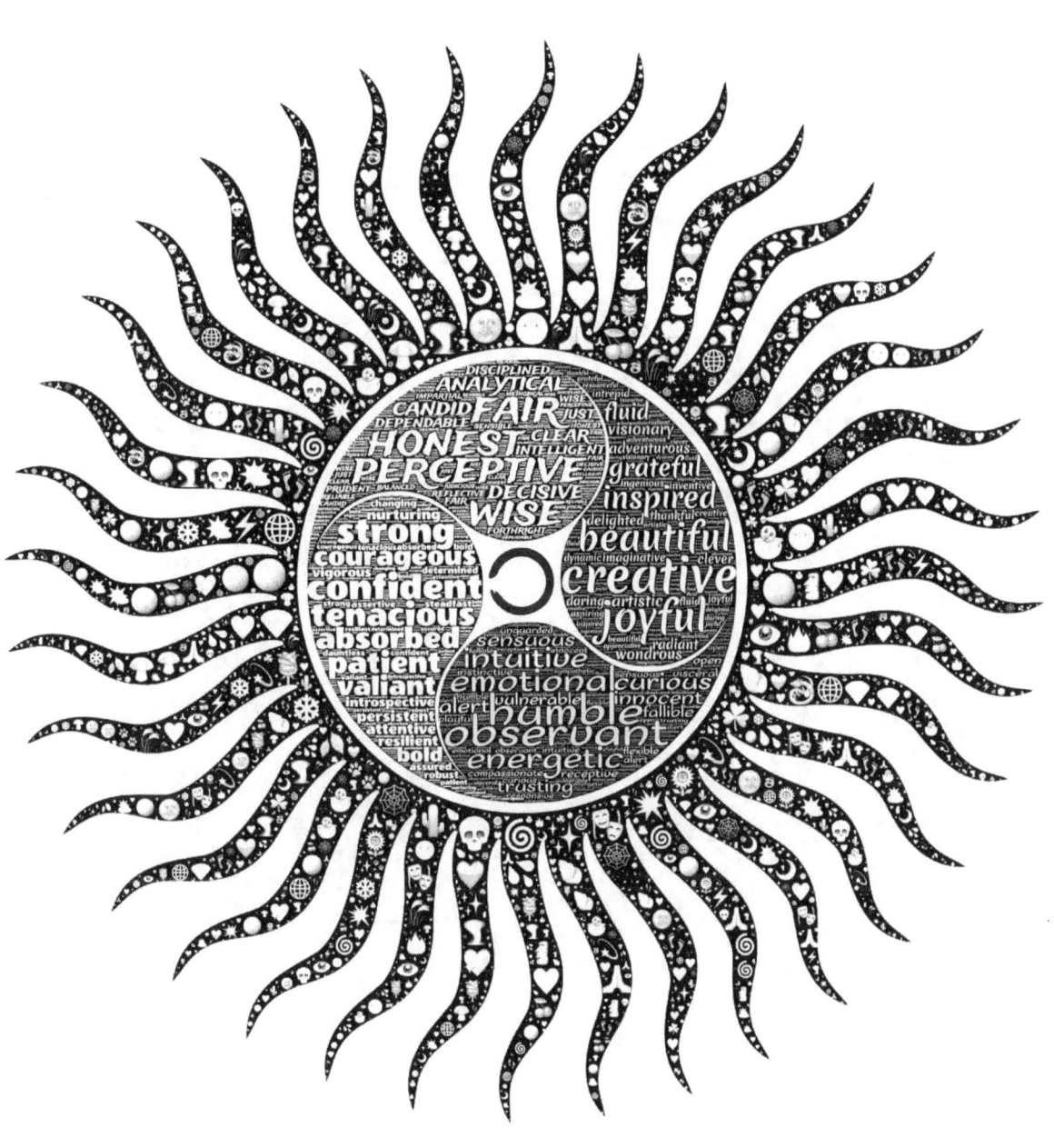

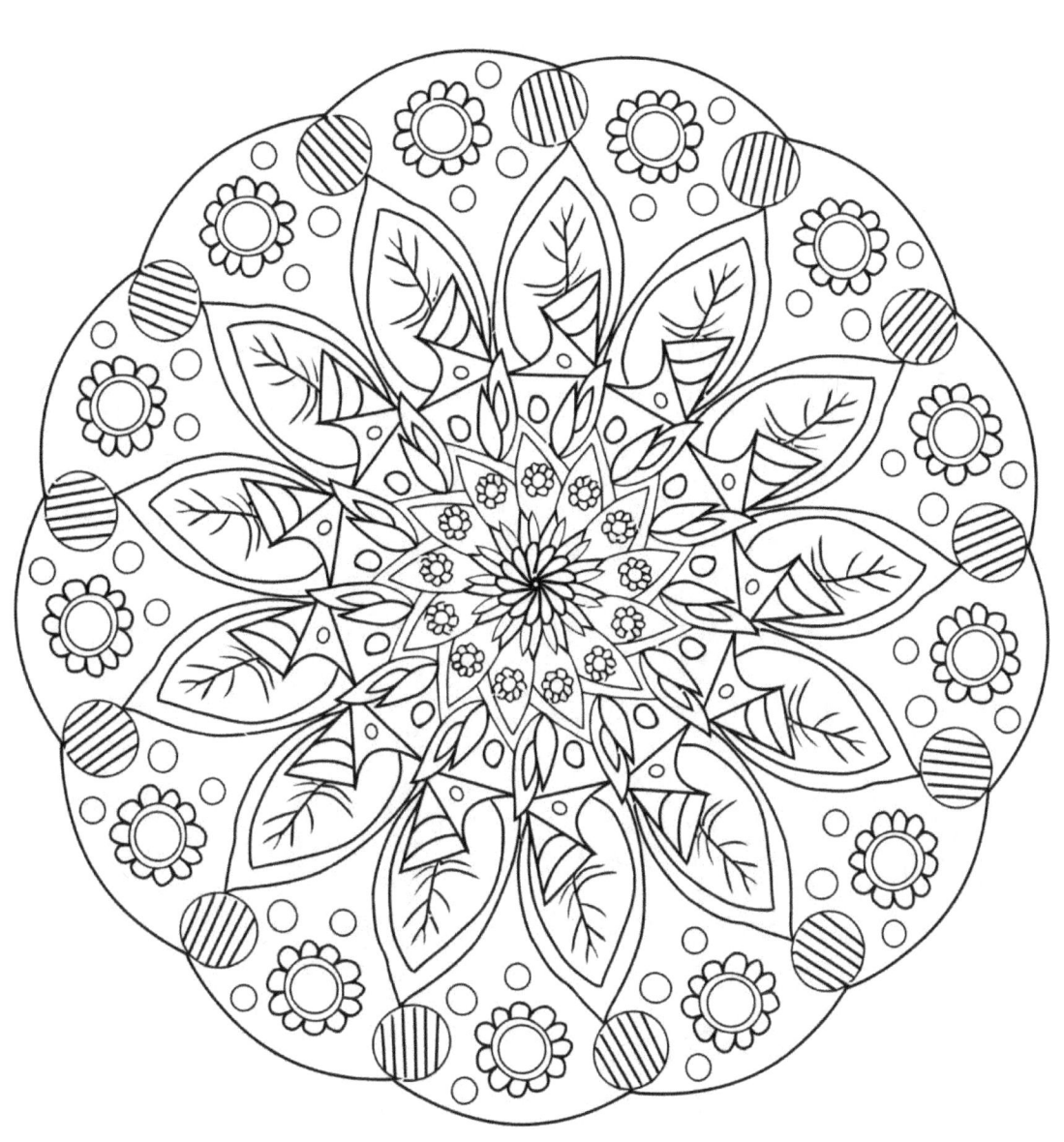

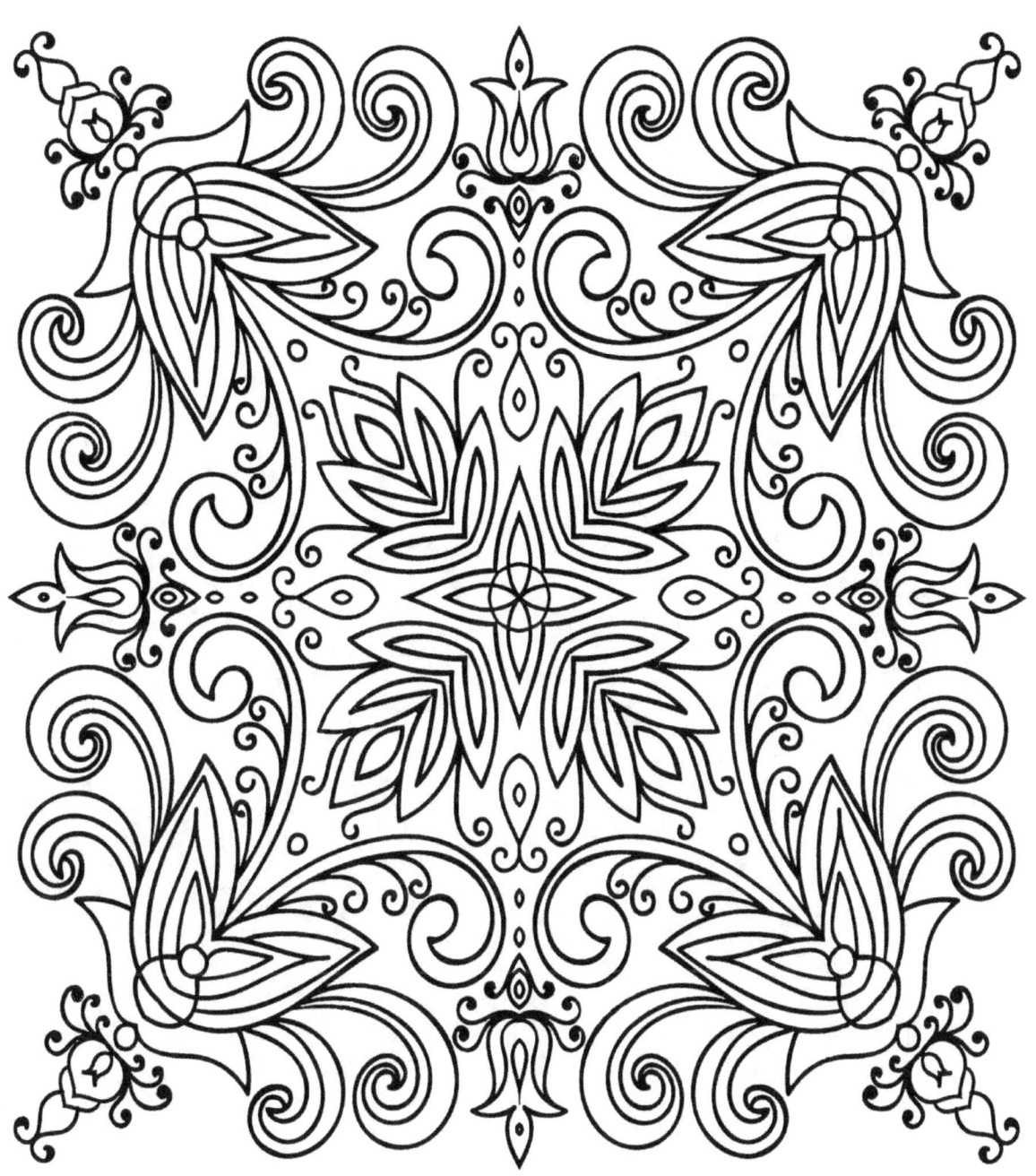

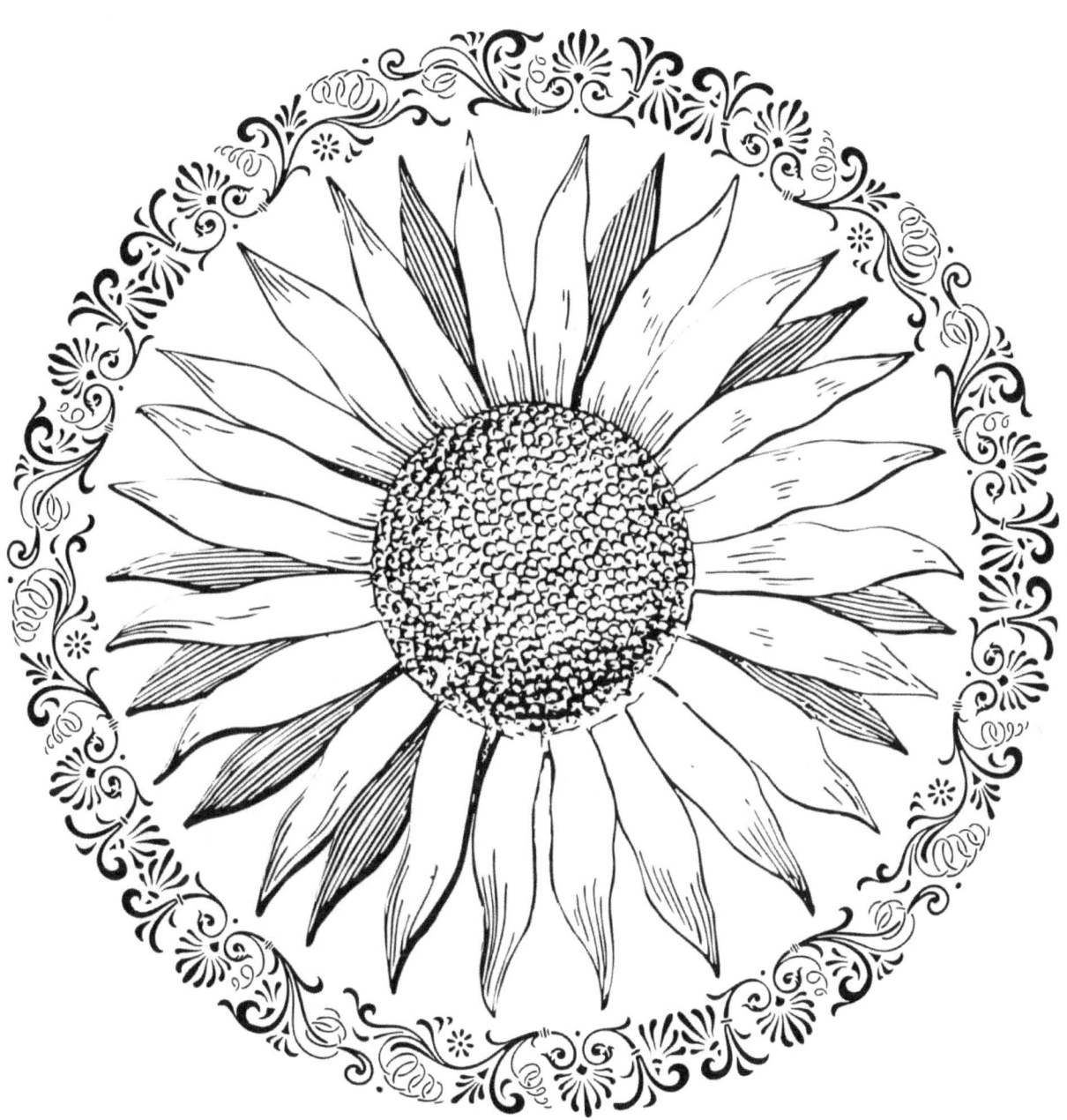

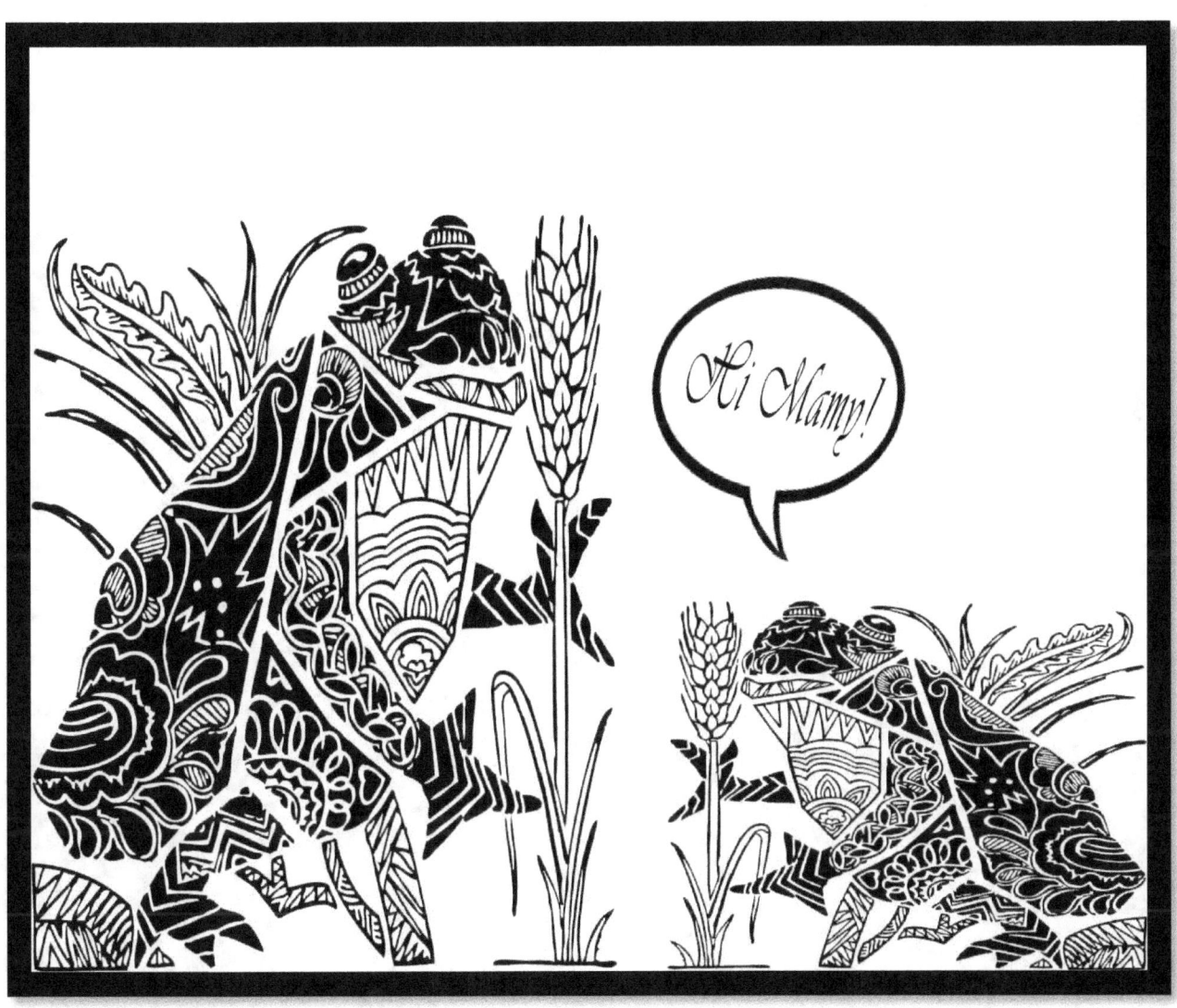

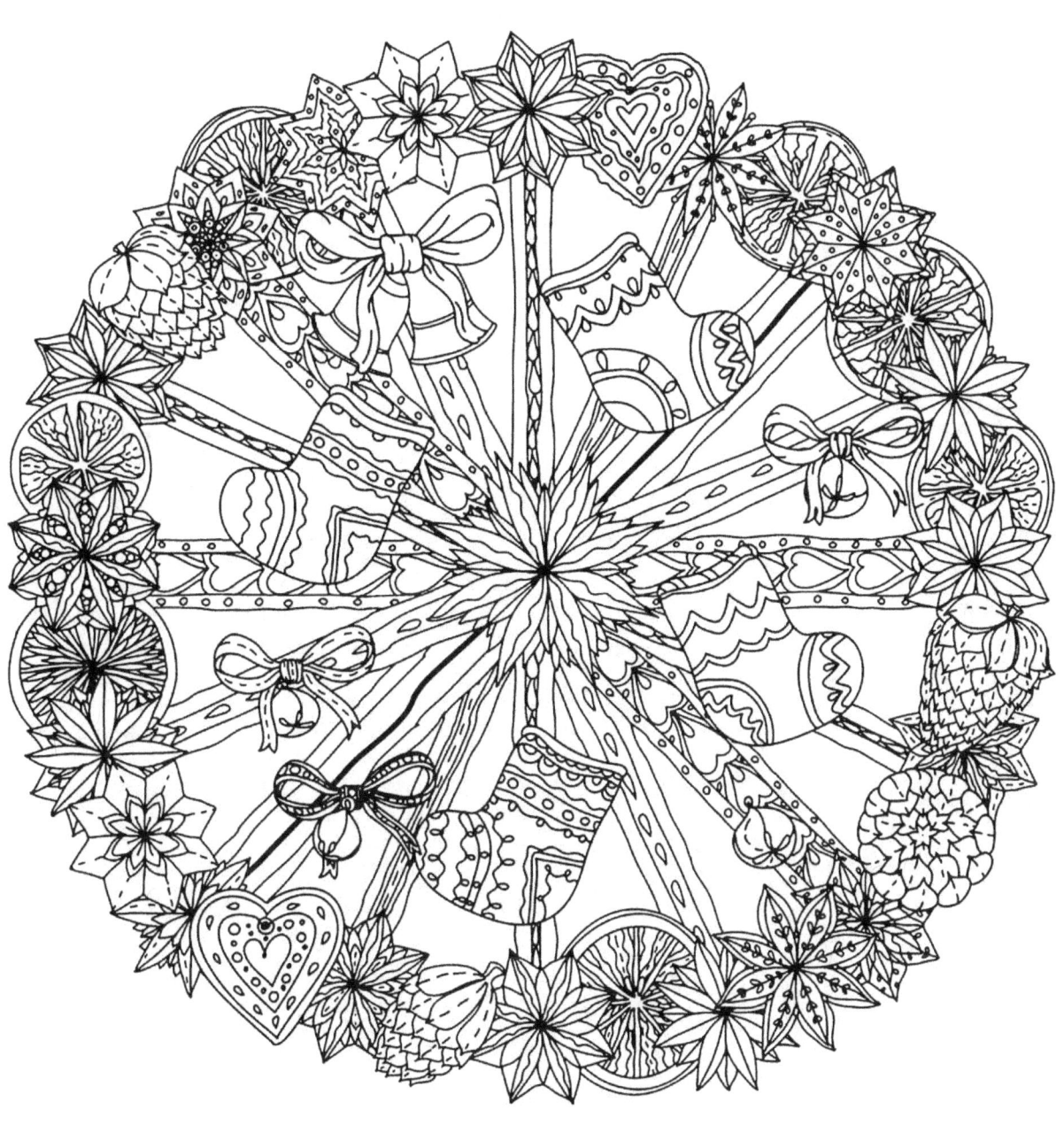

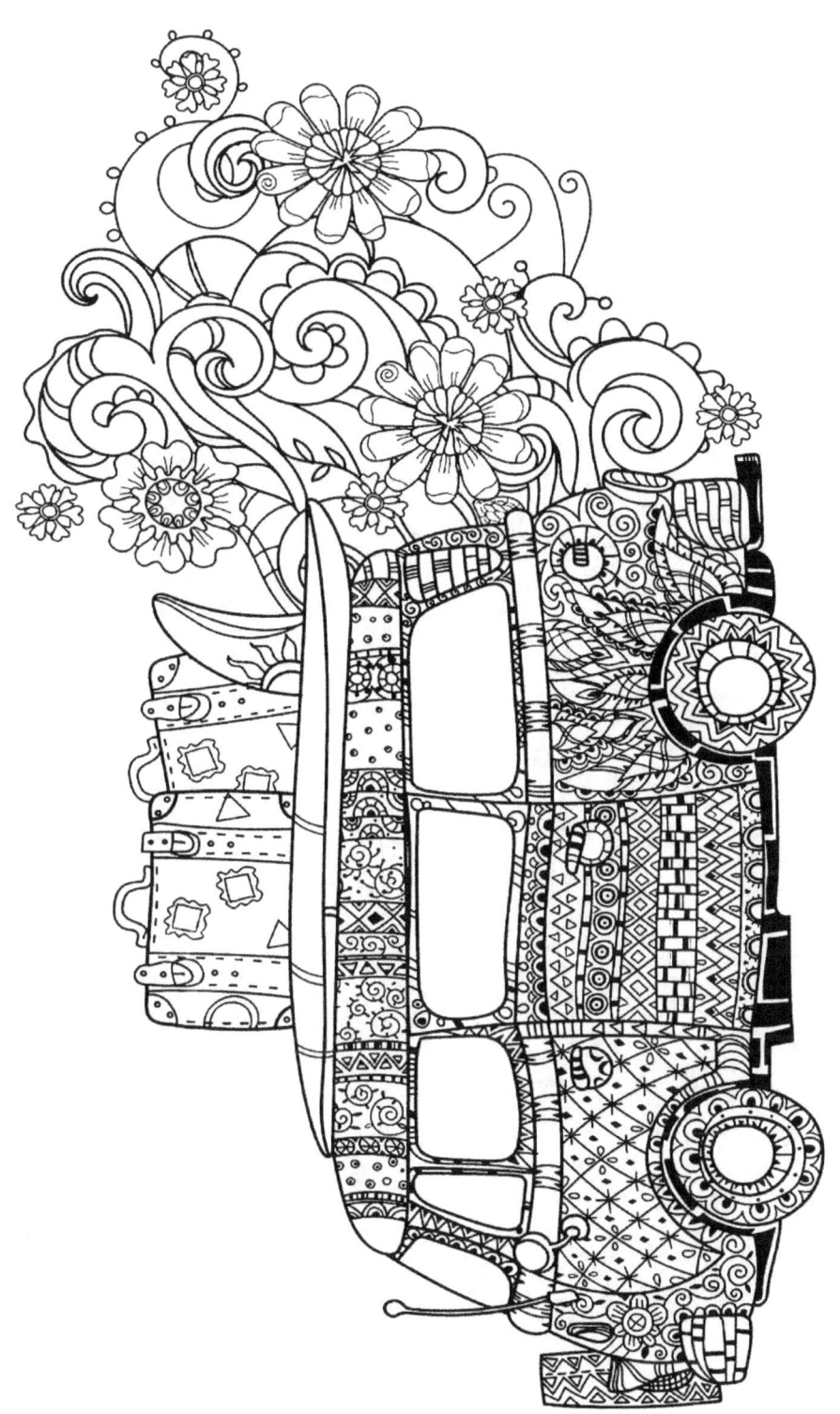

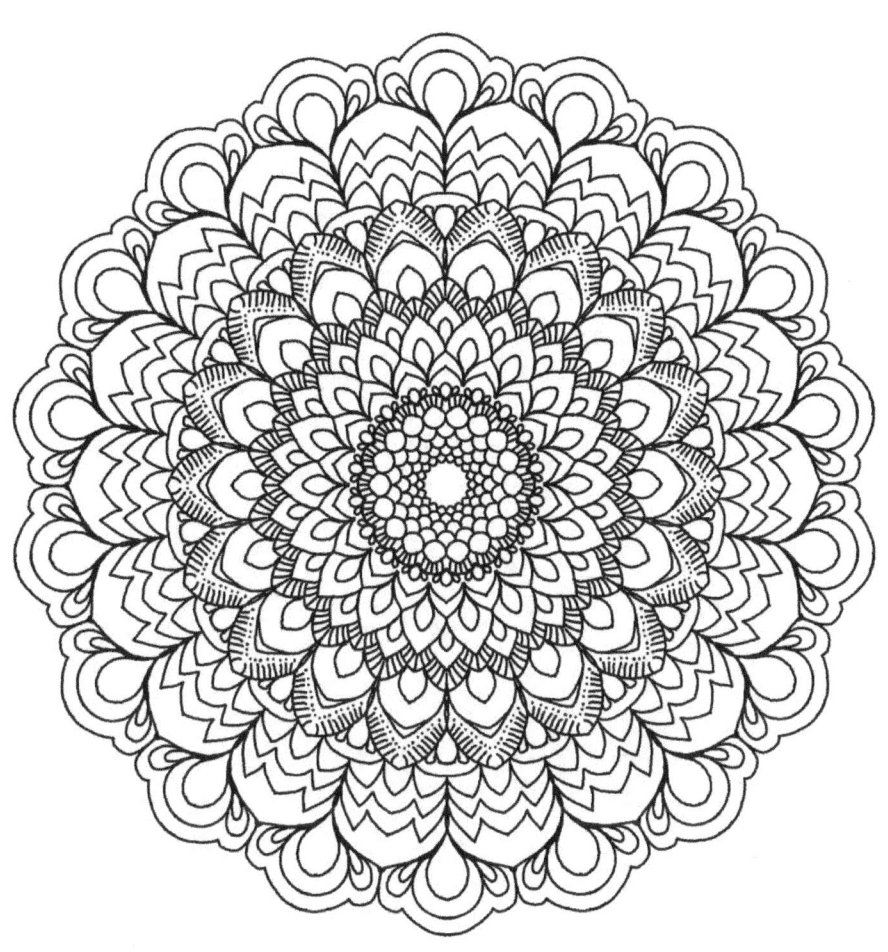

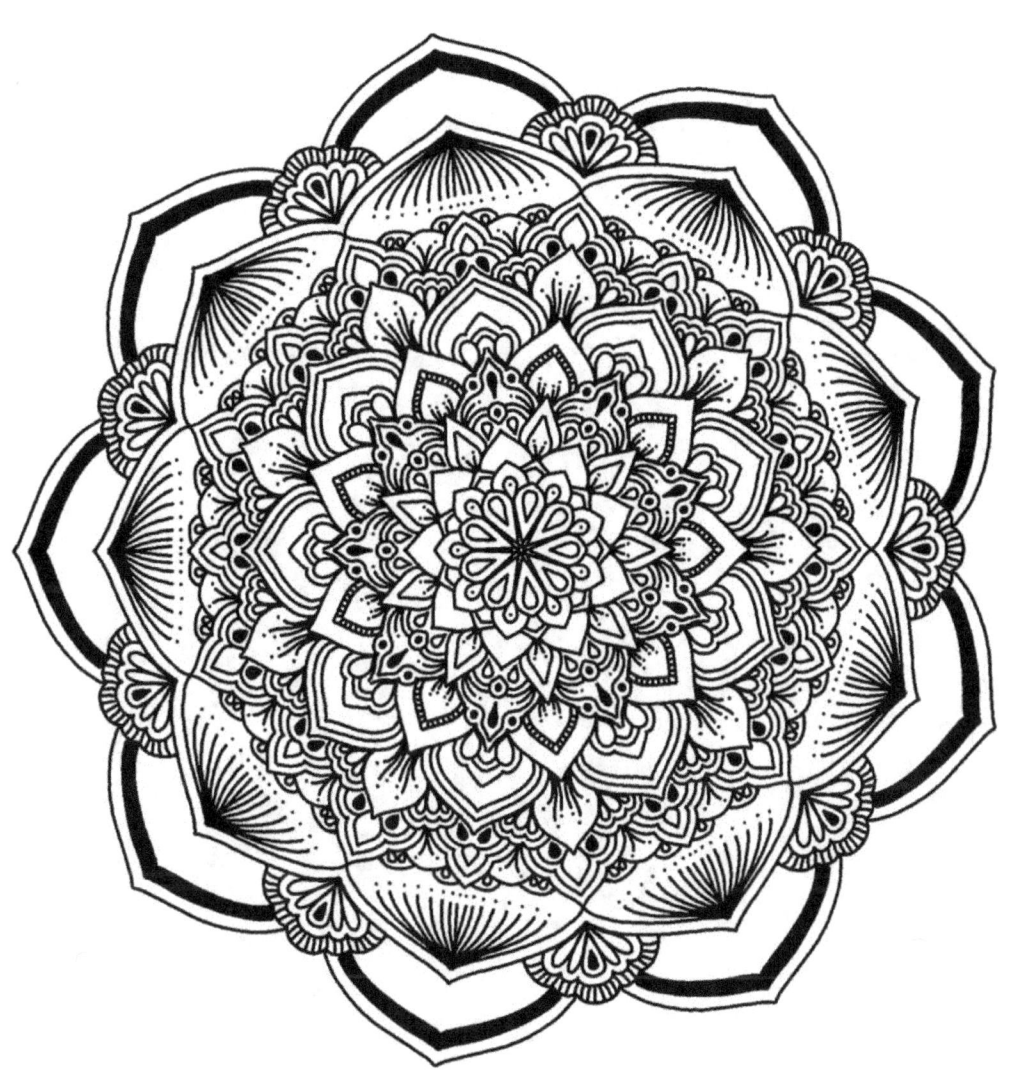

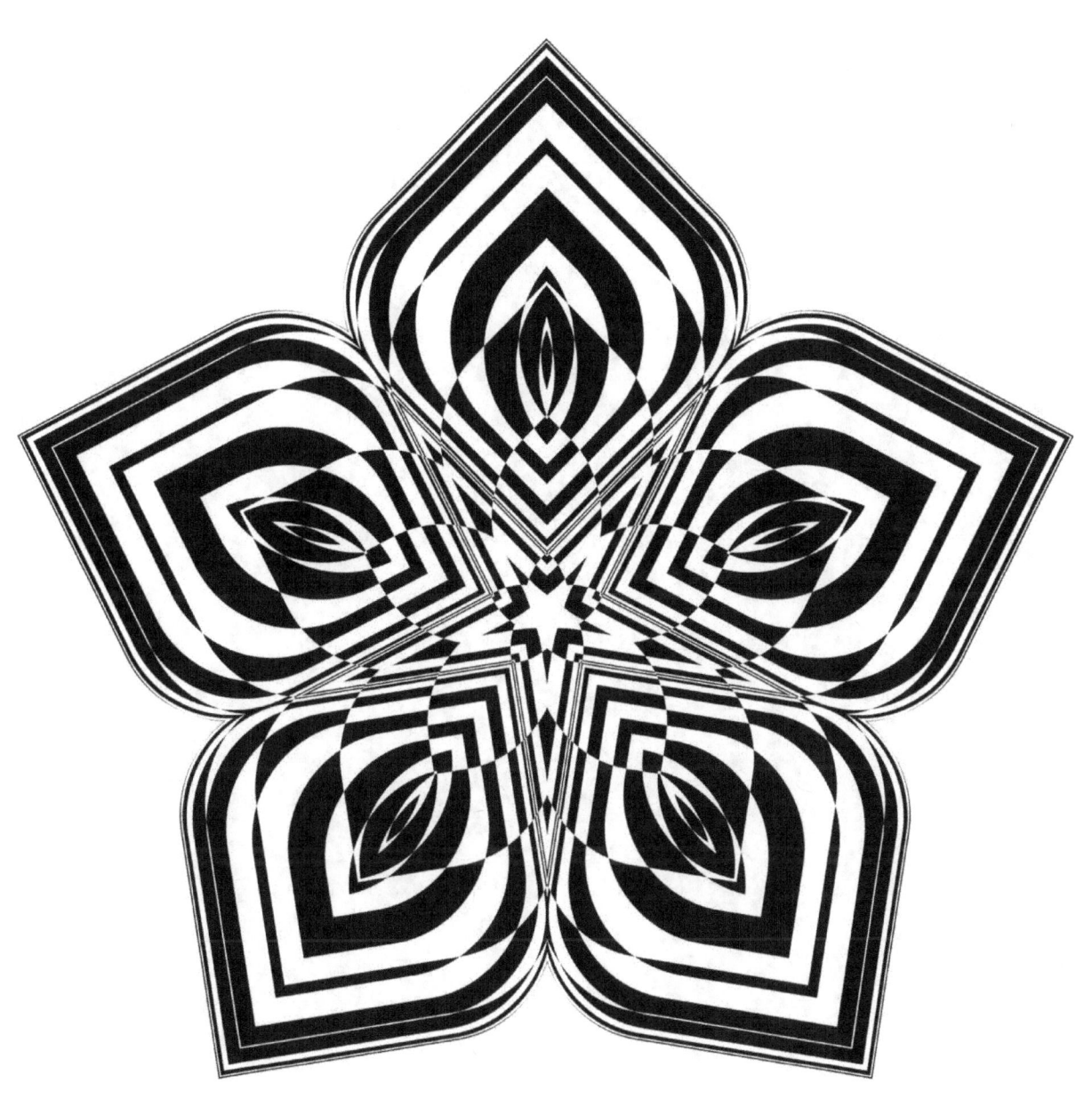

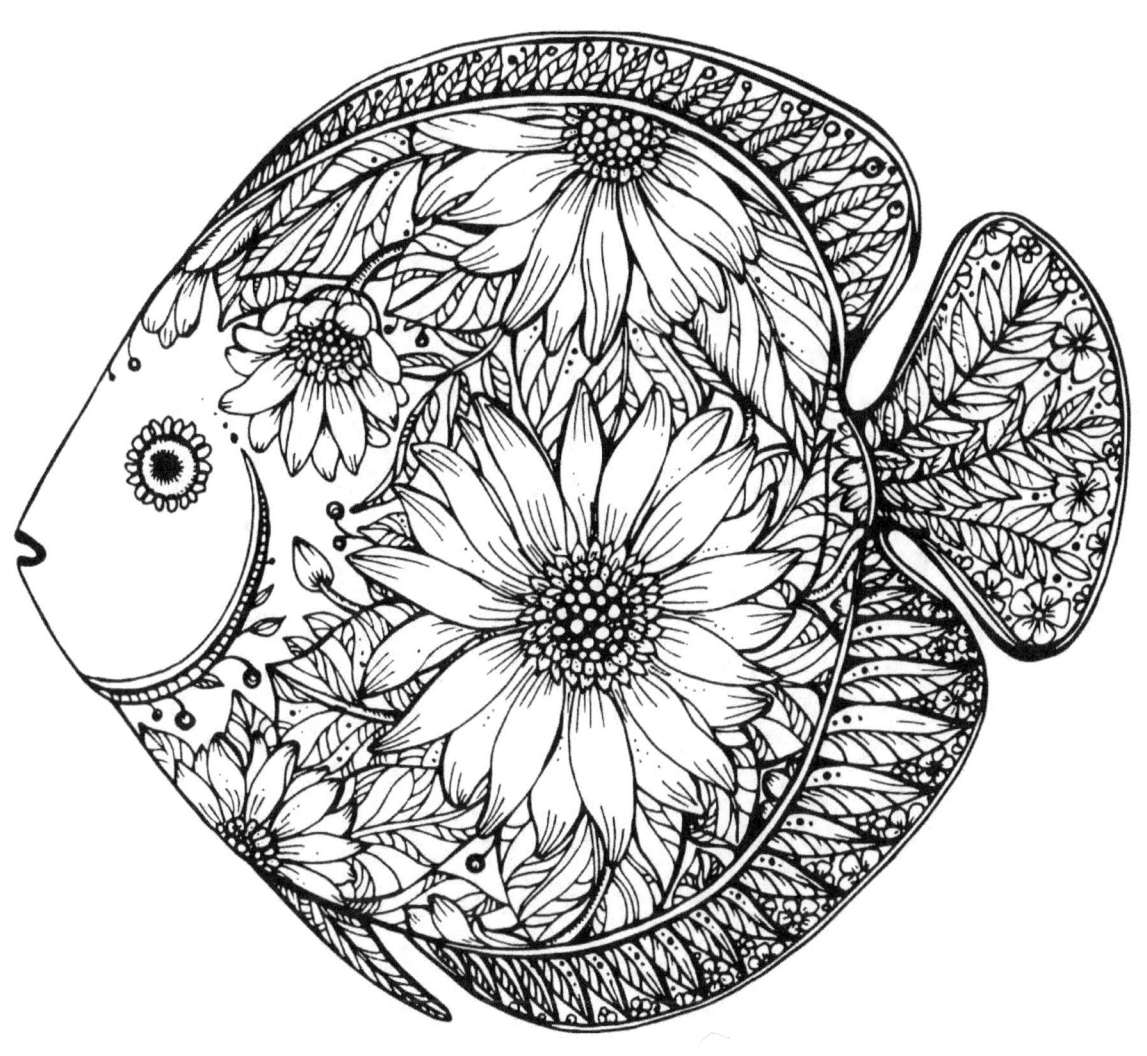

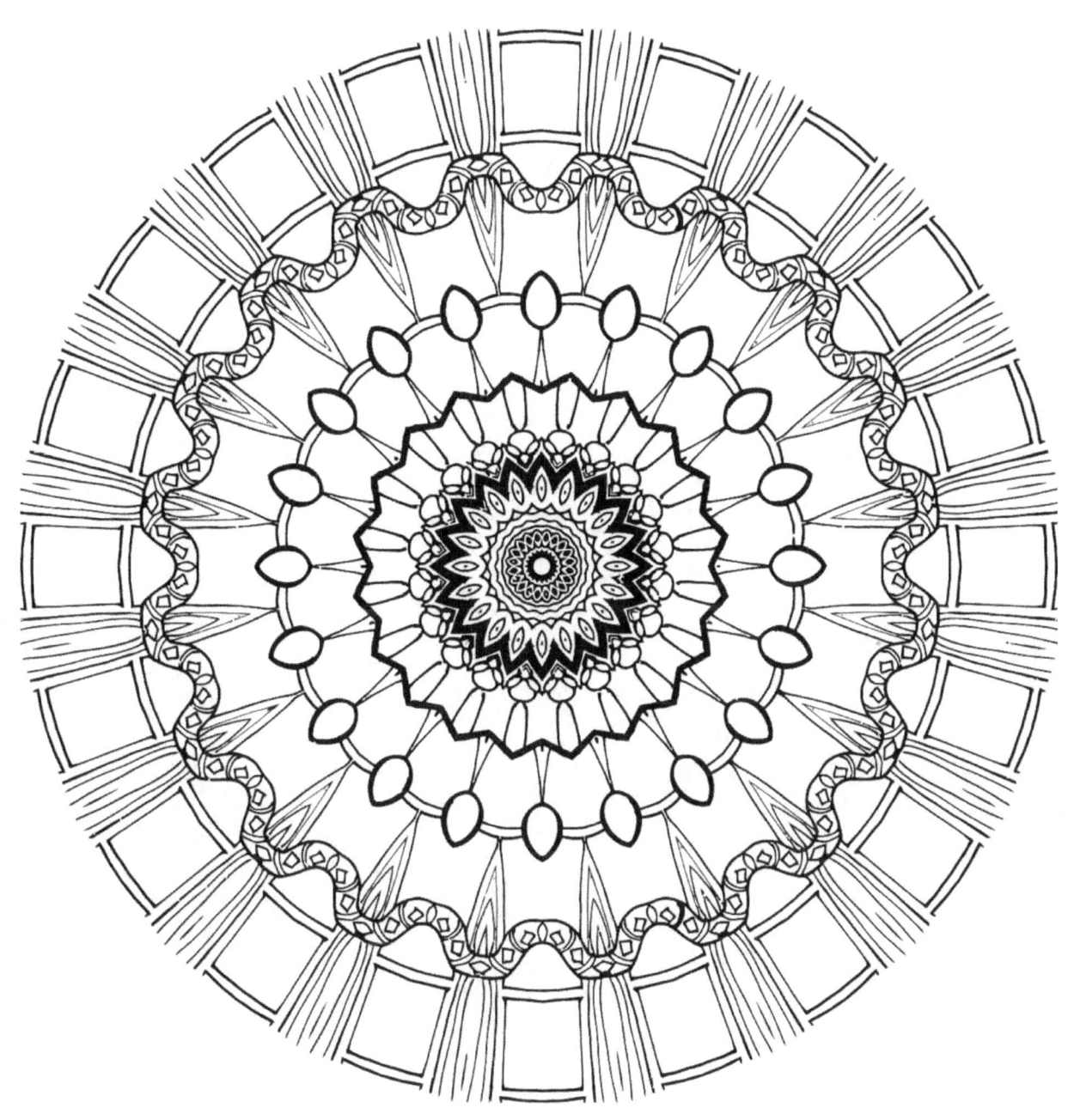

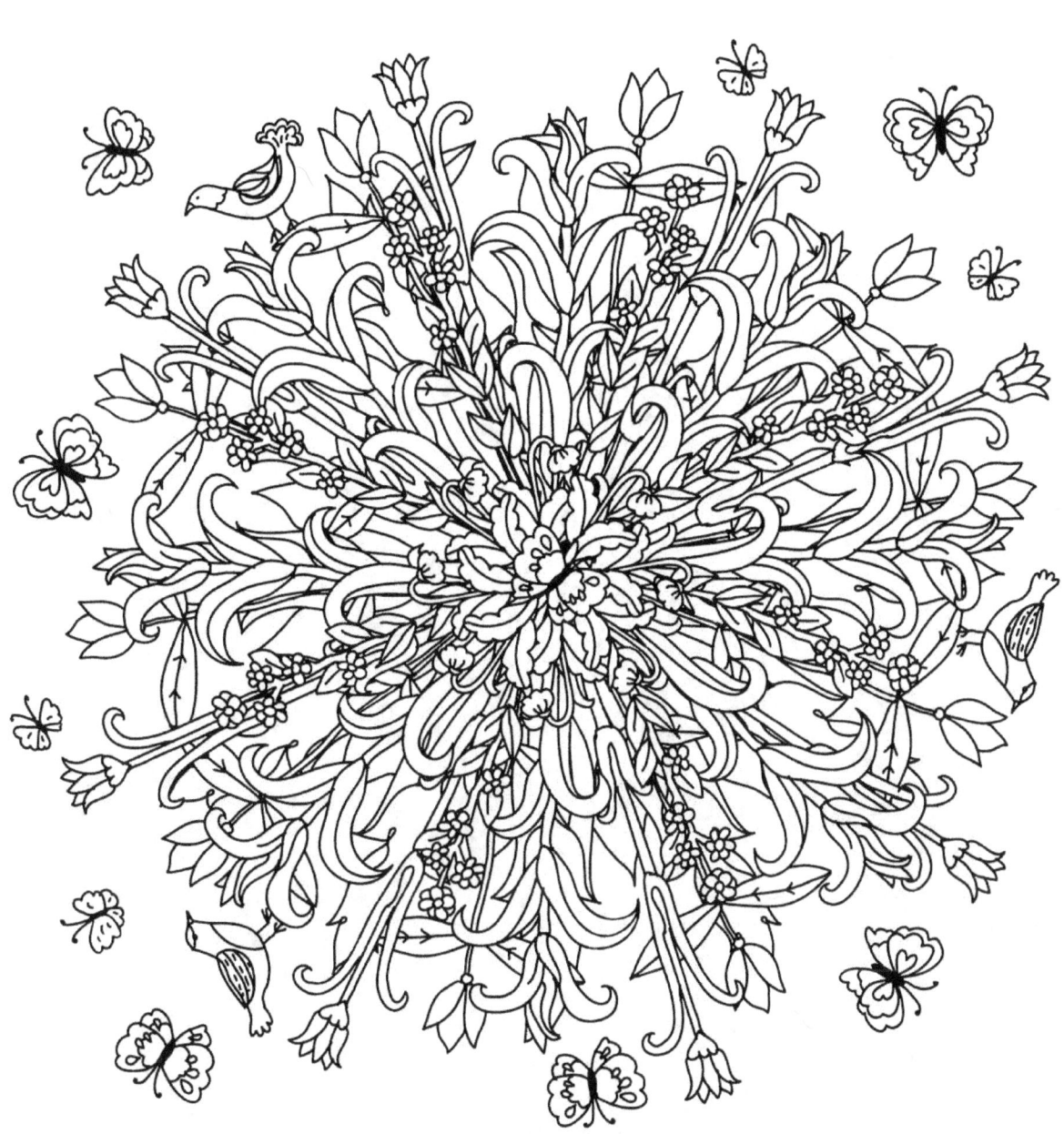

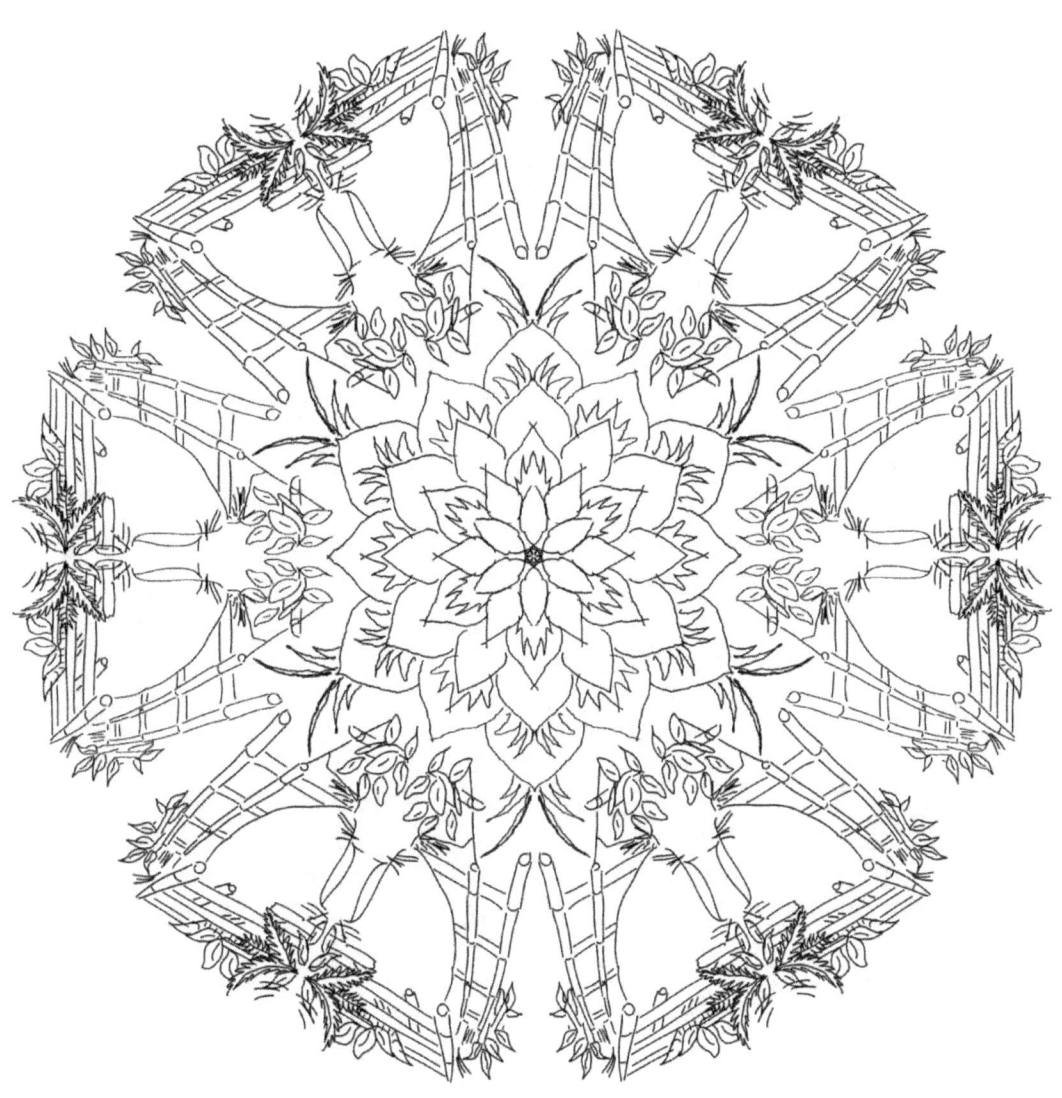

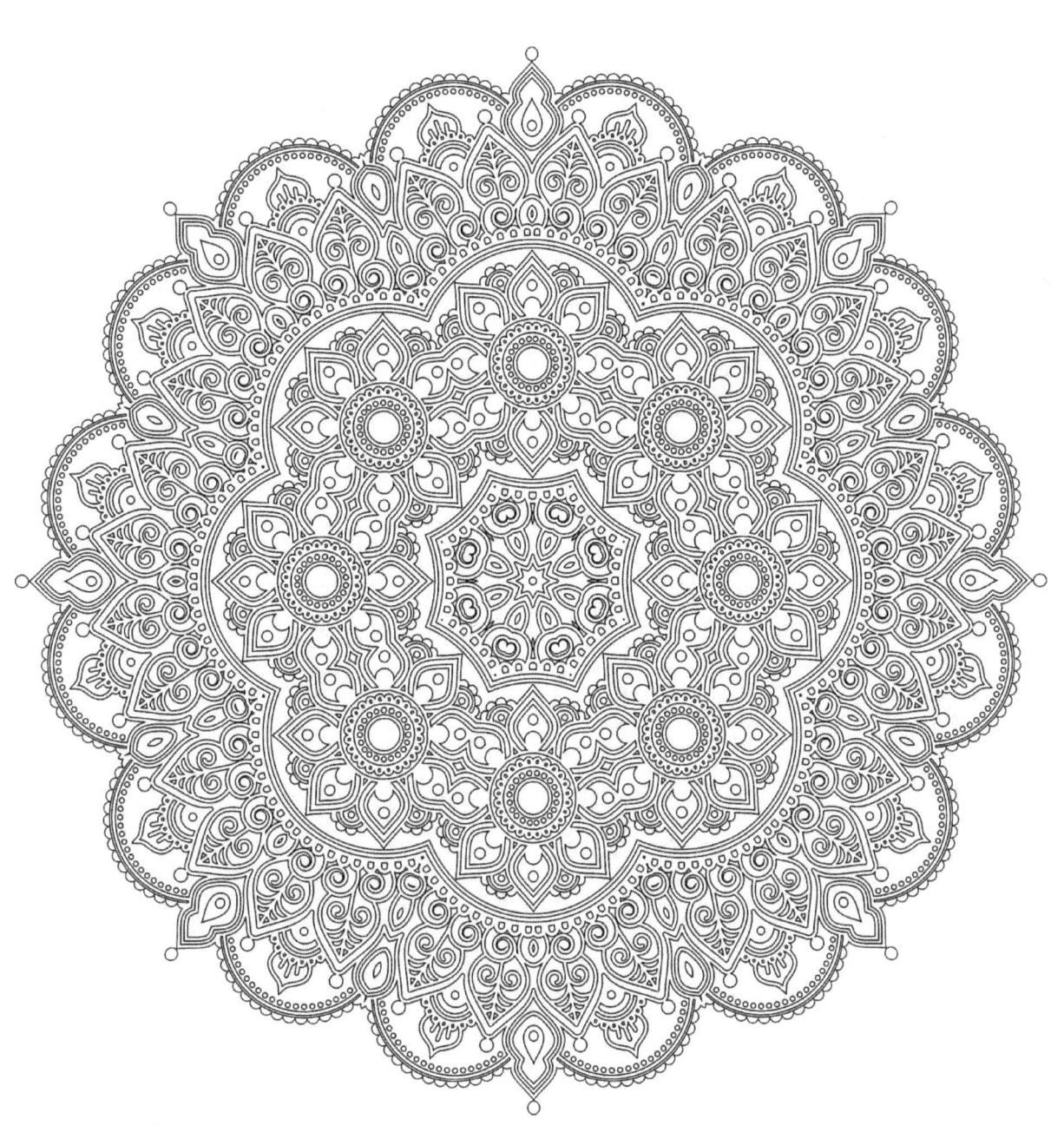

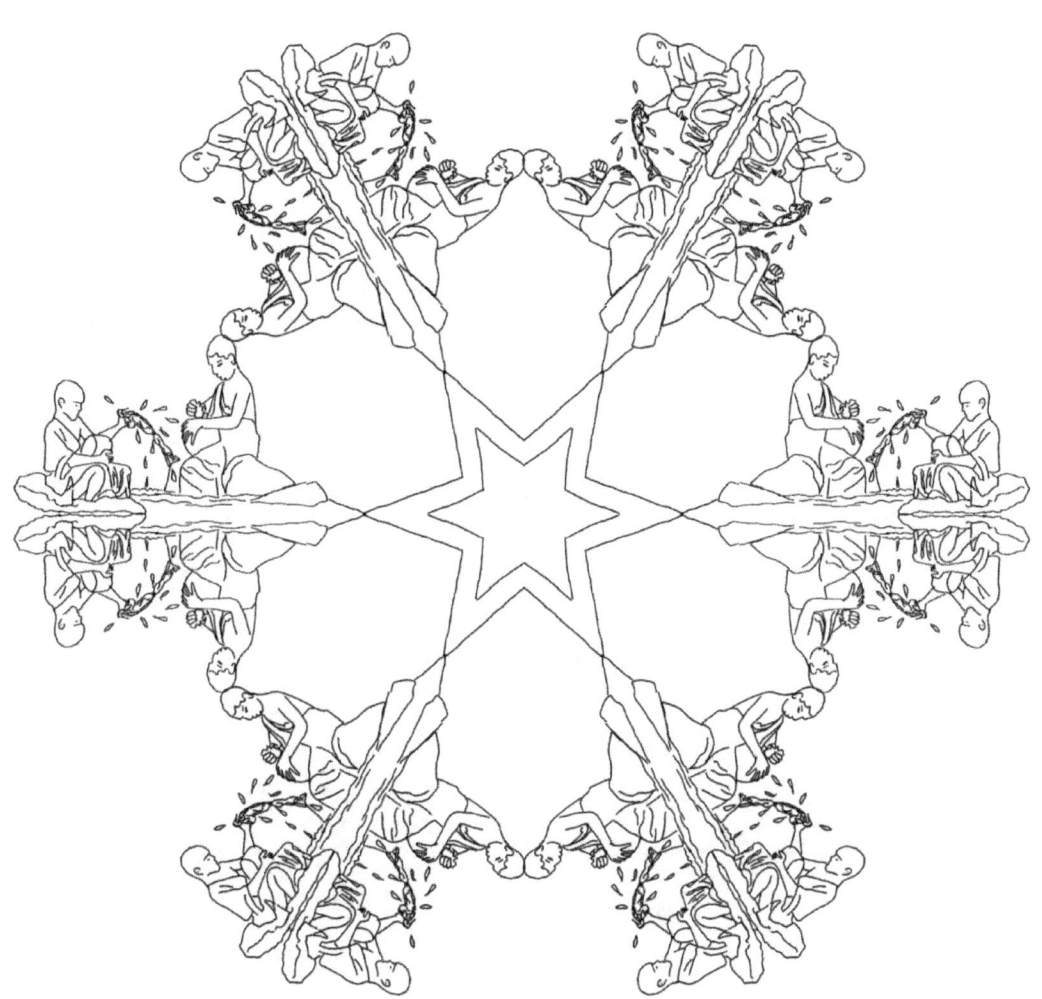

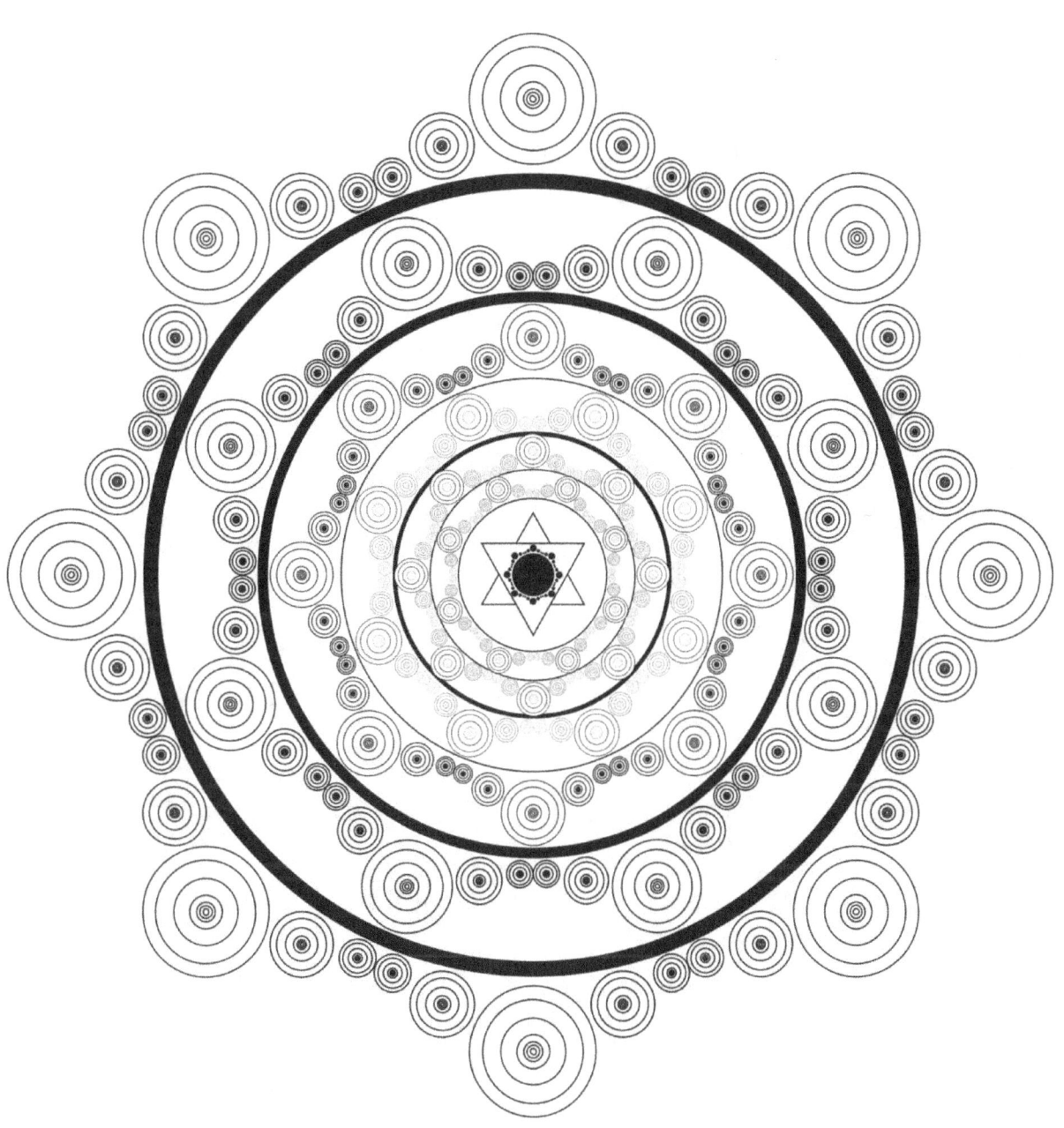

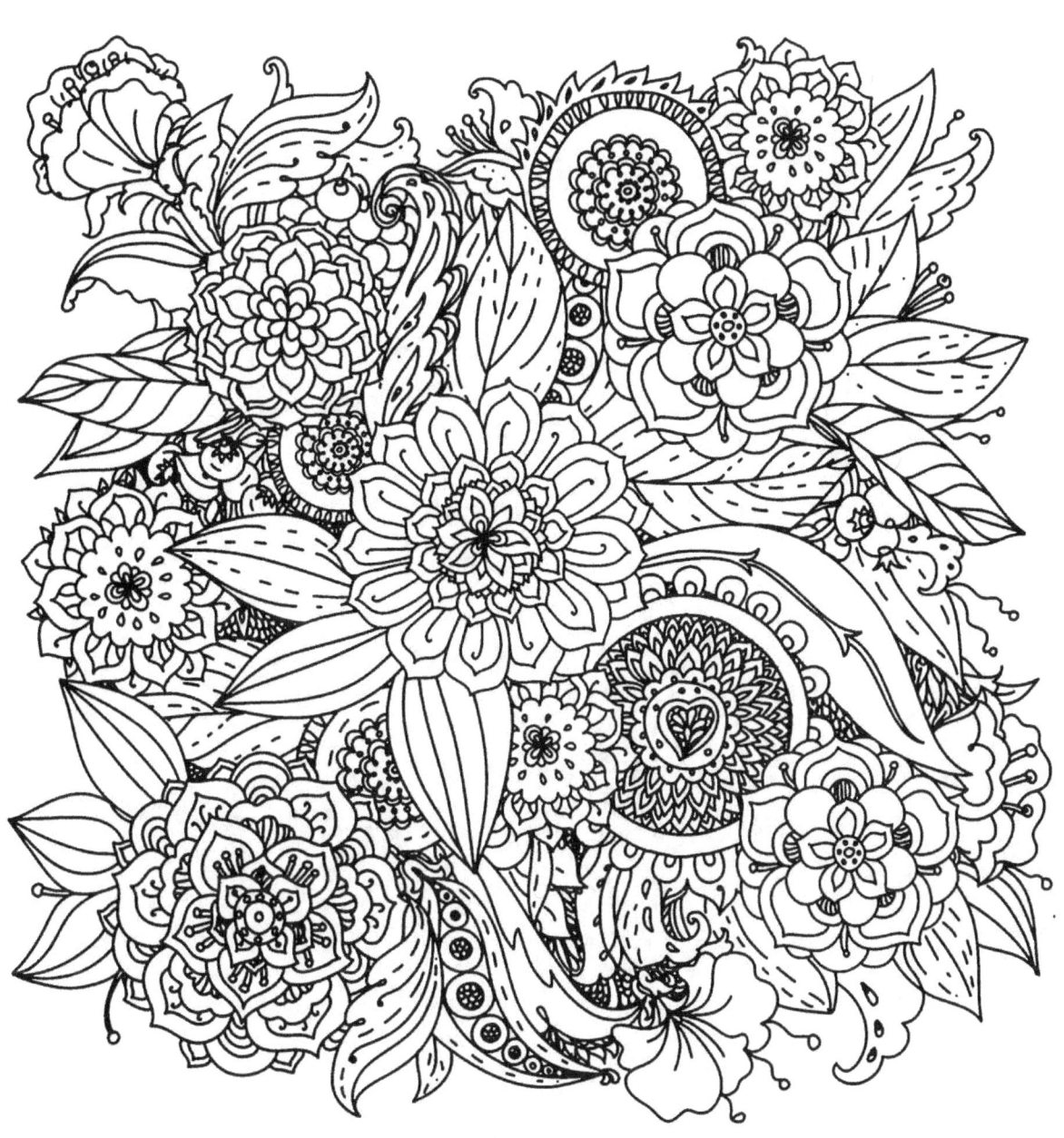

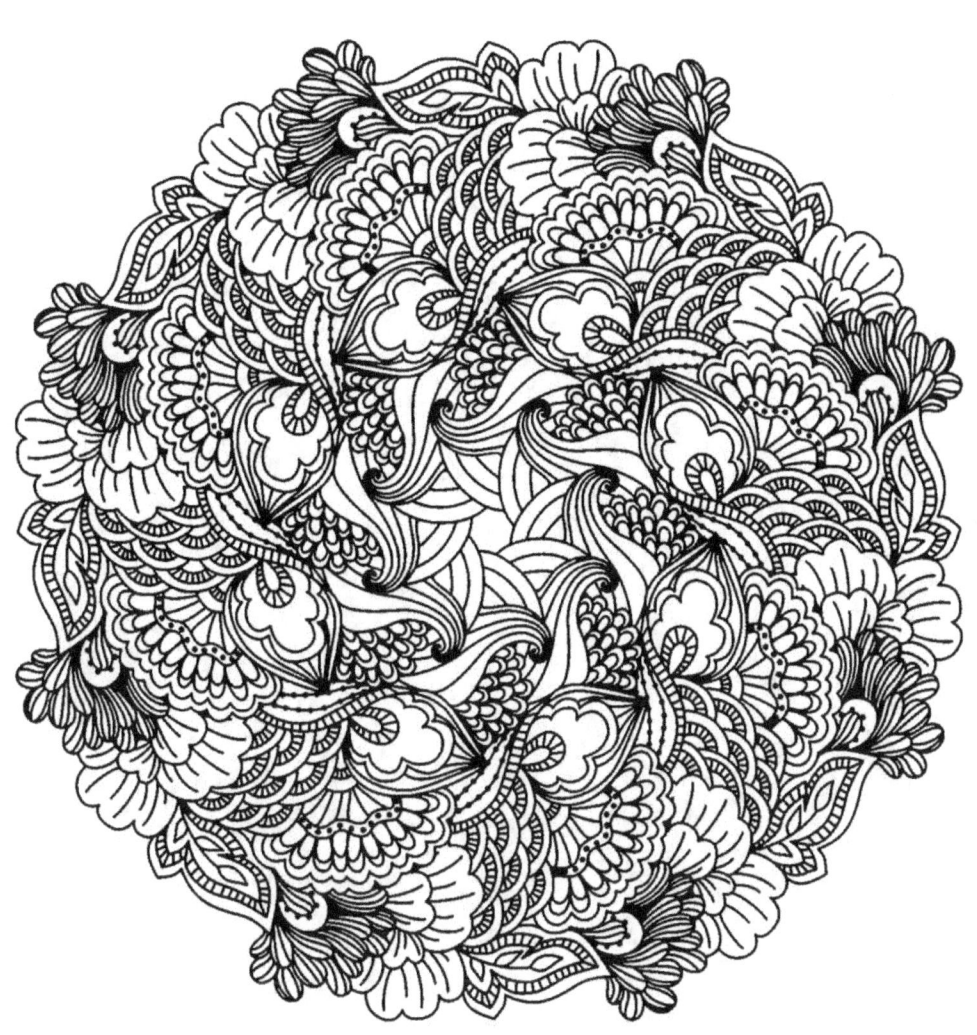

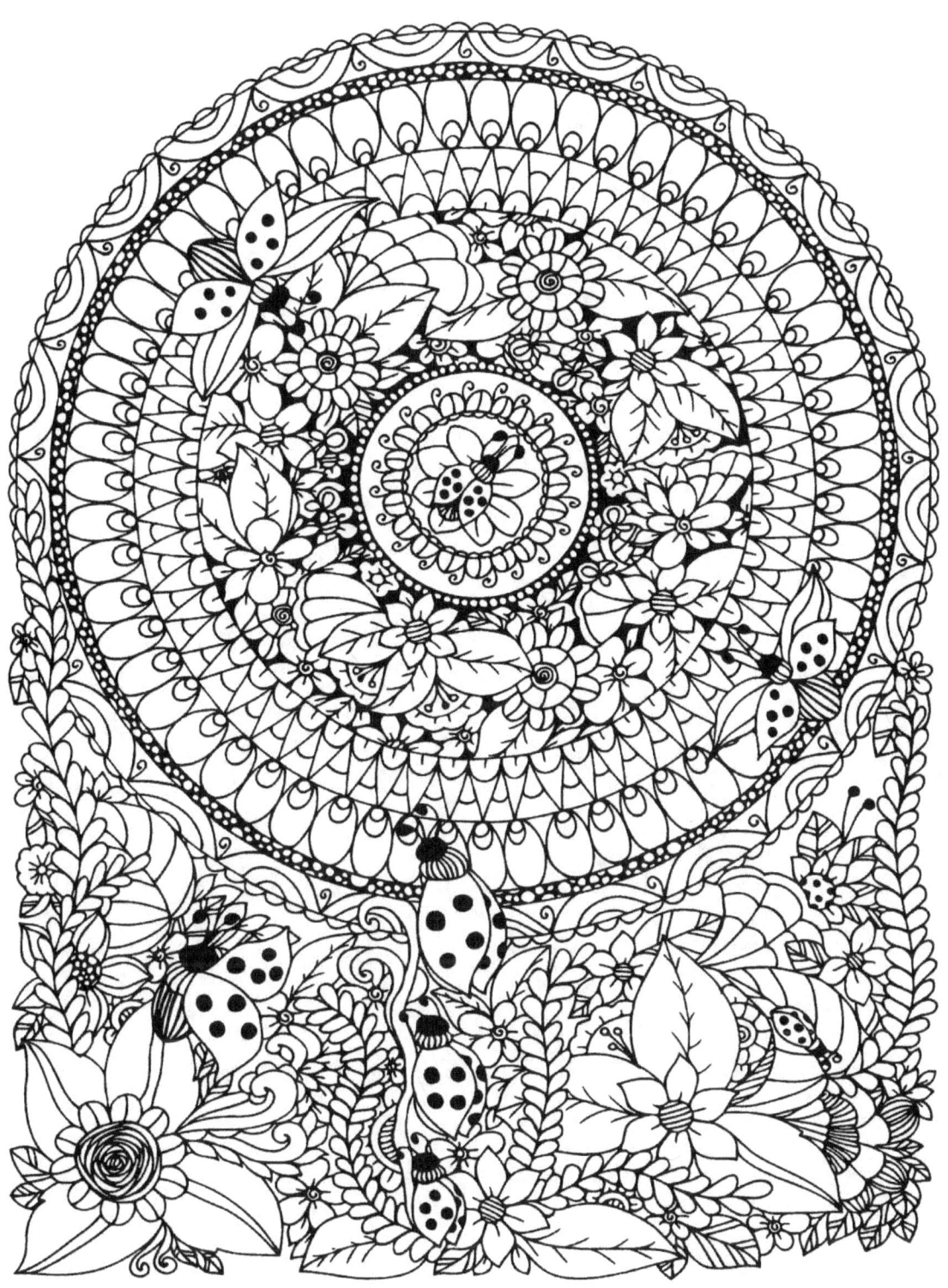

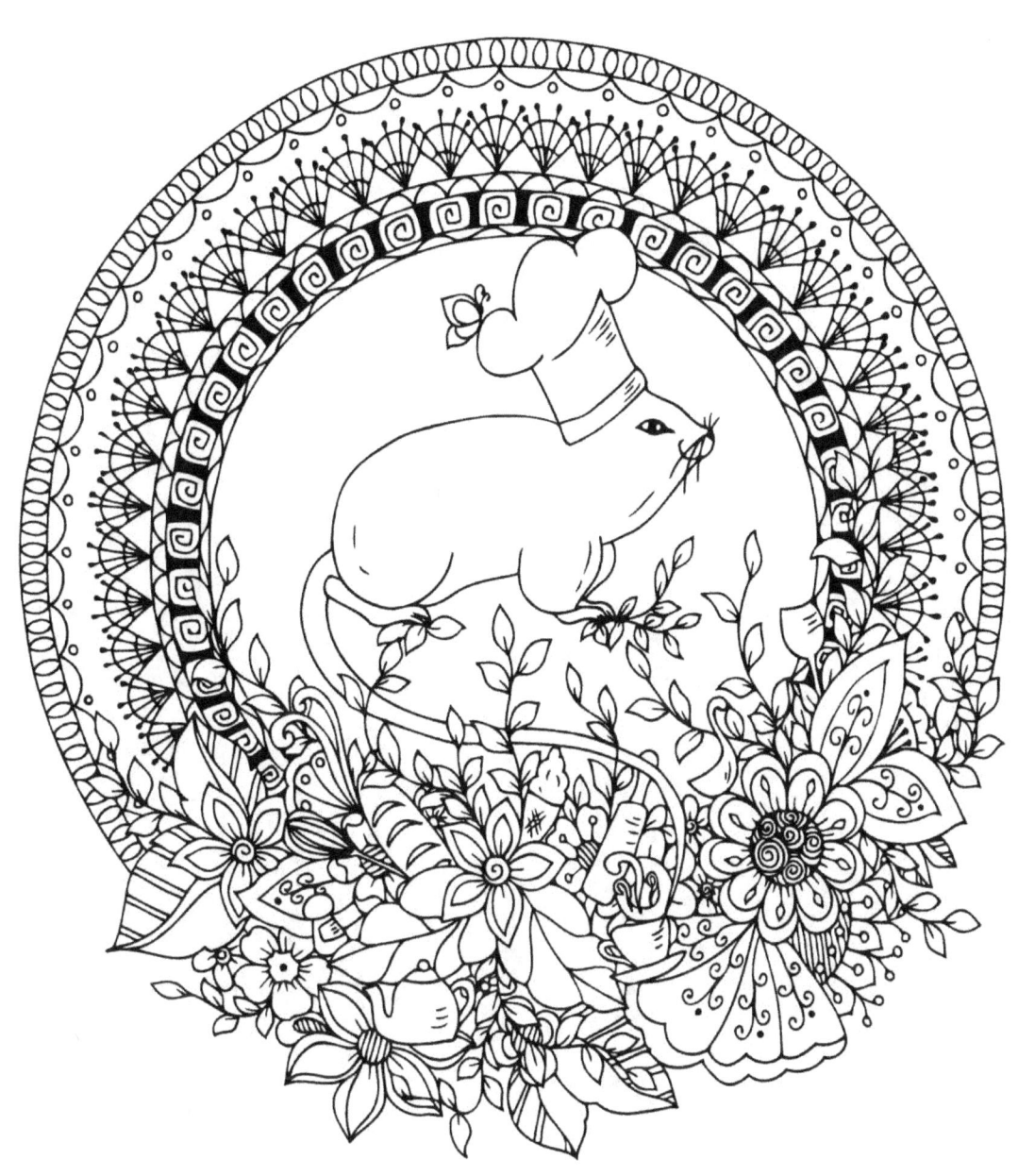

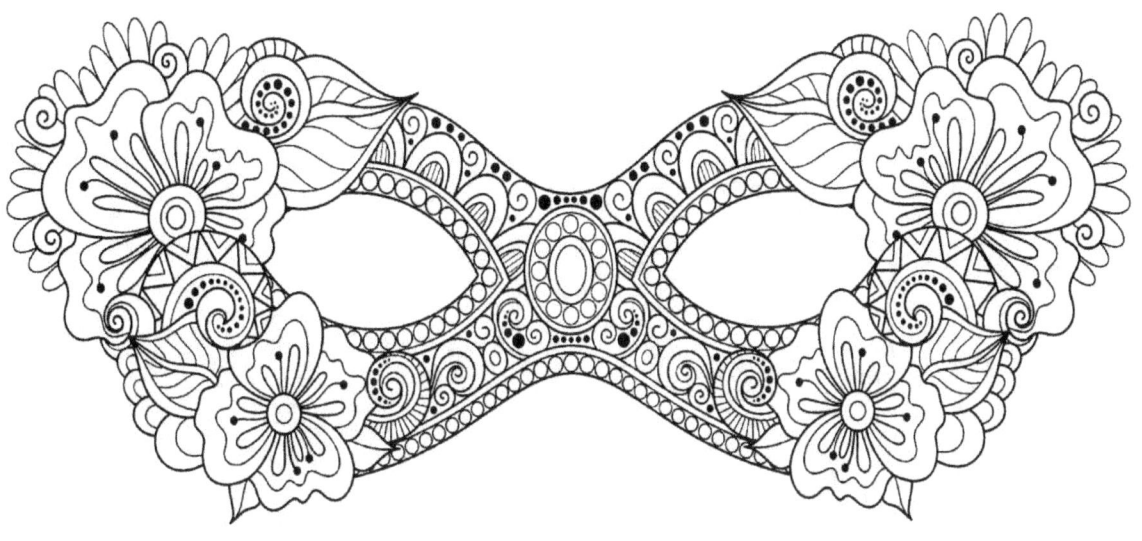

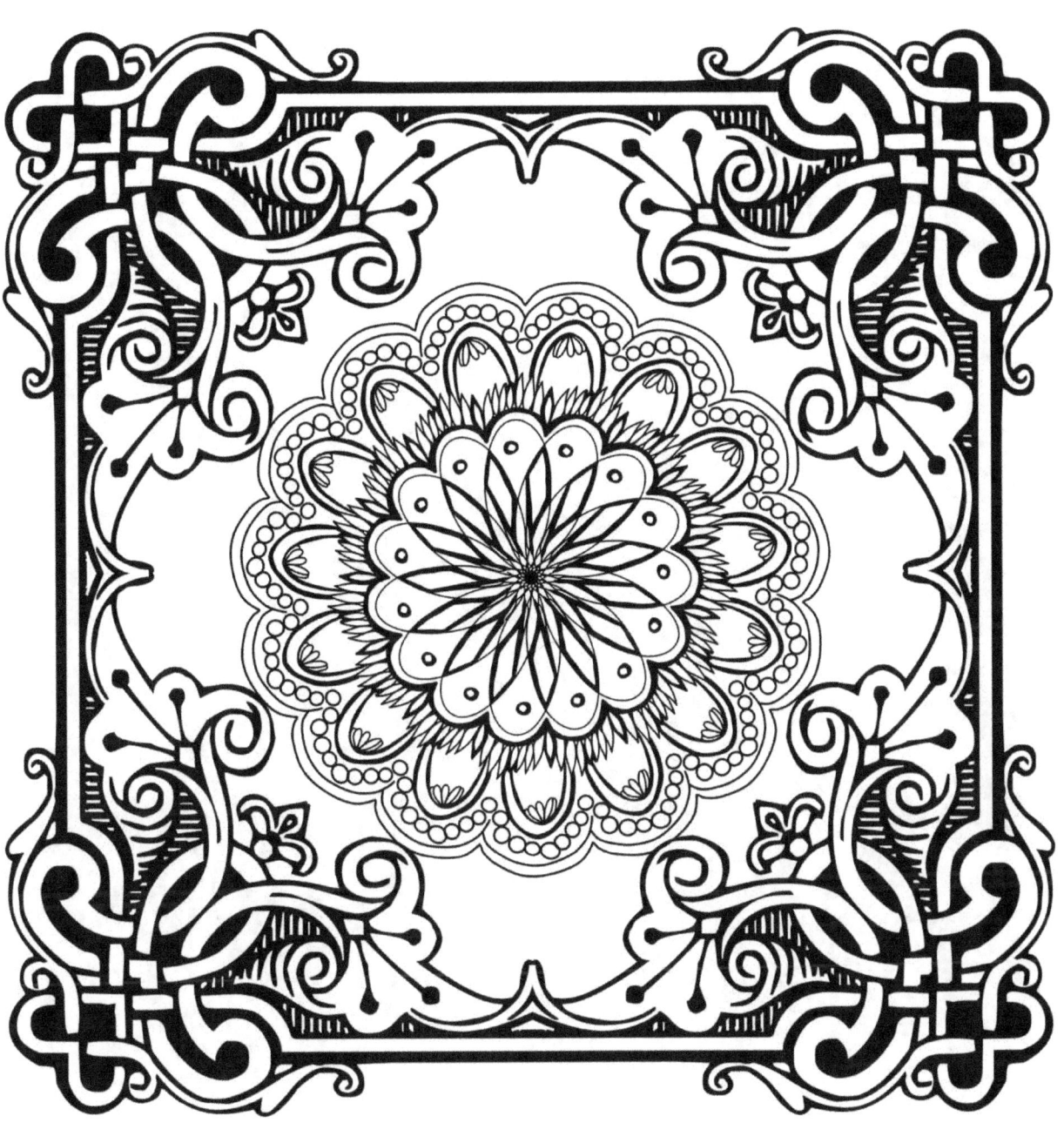

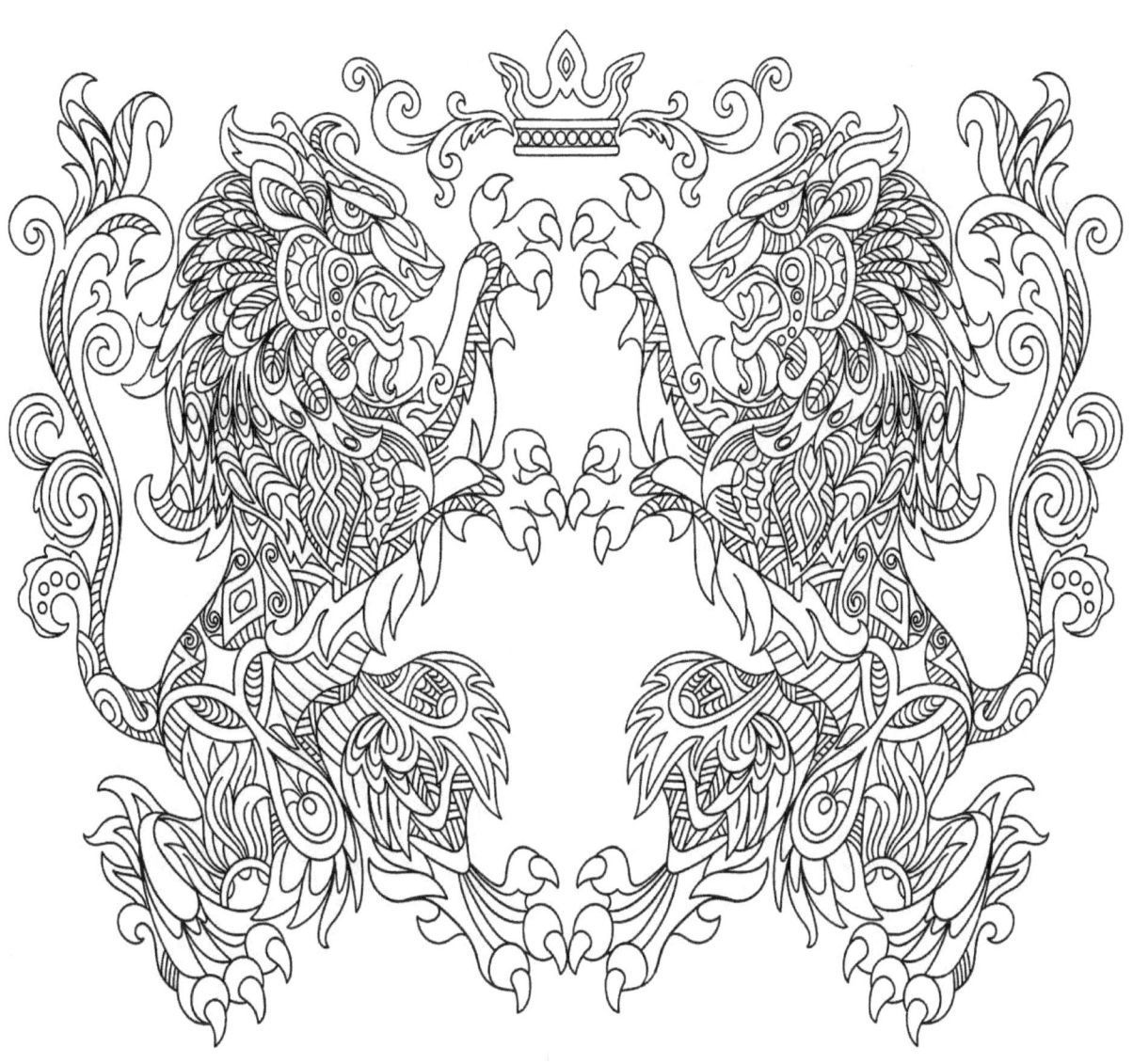

Checkout other Coloring Books for Adults by Engy Khalil:

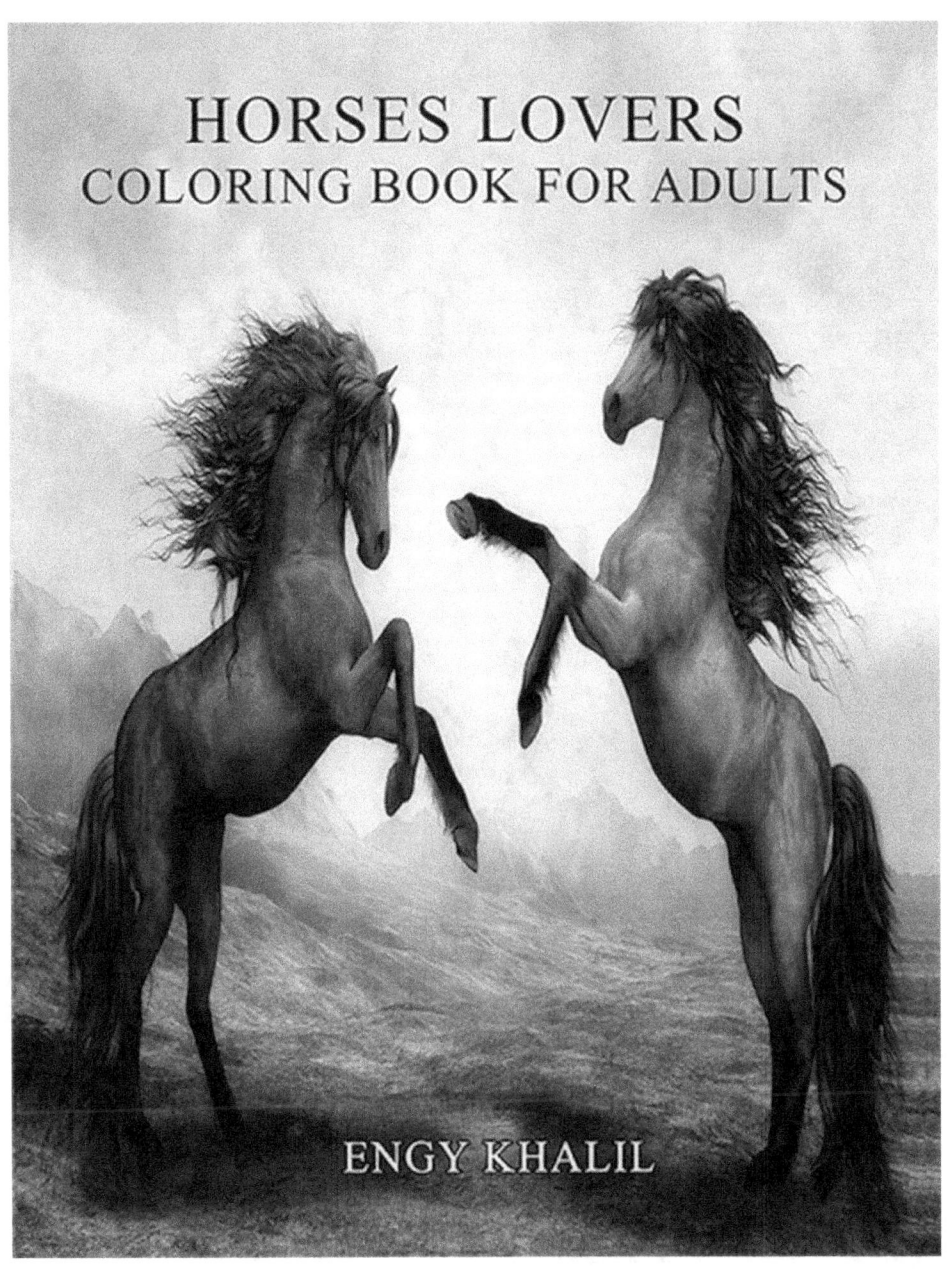

A collection of 53 Grayscale Horses Plus Free Bonuses

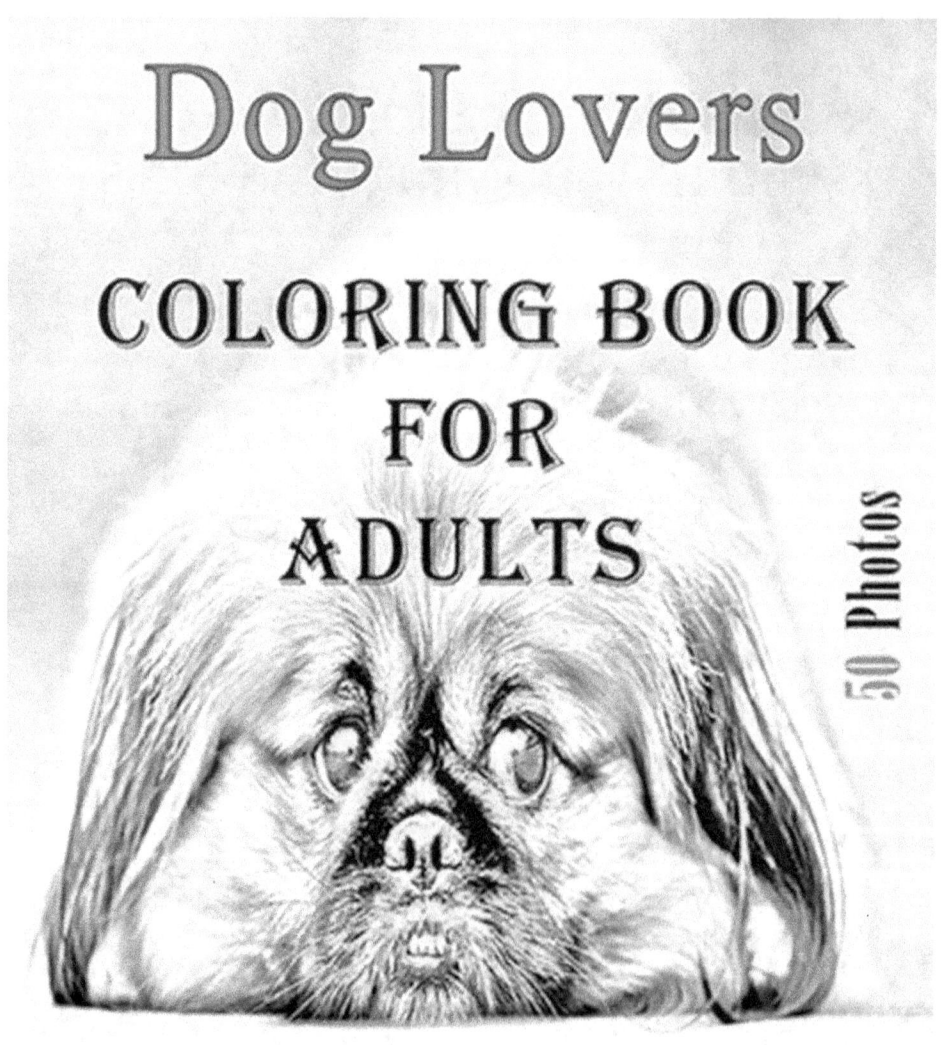

A collection of 50 Grayscale Dogs Plus Free Bonuses

Keep in Touch

For more coloring books for adults, coloring ideas, tips and free coloring pages visit us at:

Adultscoloringbook.net

For coloring books and notebooks store visit us at:

Ordercoloringbook.com

Note:

If you liked this book please write your review.

Hope you enjoyed the book!

Engy Khalil

Test Your Colors Here:

Test Your Colors Here:

Test Your Colors Here:

www.ingramcontent.com/pod-product-compliance
Lightning Source LLC
Chambersburg PA
CBHW062355220526
45472CB00008B/1820